IMAGES OF ENGLAND

AROUND
HEREFORD

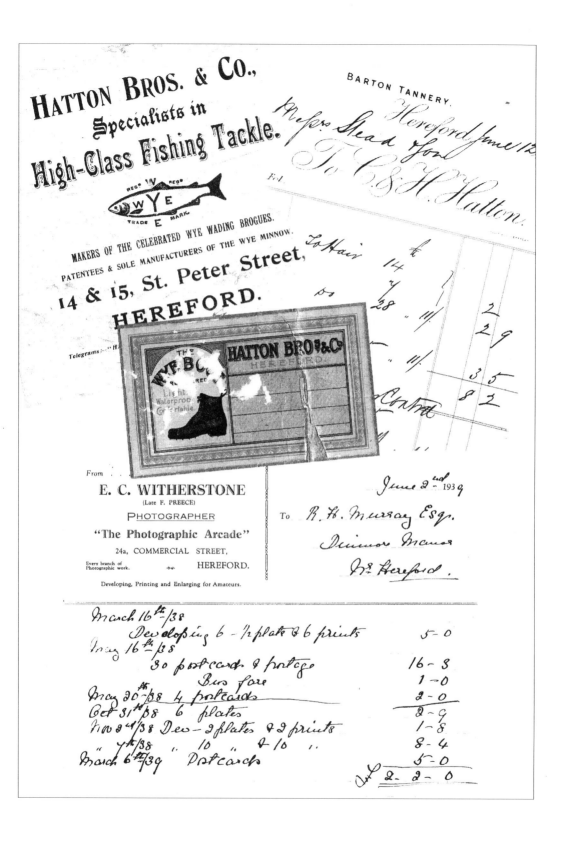

HATTON BROS. & CO.,
Specialists in
High-Class Fishing Tackle.

REG^D W E REG^D
WYE
TRADE E MARK

MAKERS OF THE CELEBRATED WYE WADING BROGUES.
PATENTEES & SOLE MANUFACTURERS OF THE WYE MINNOW.

14 & 15, St. Peter Street,
HEREFORD.

Telegrams:—"H

BARTON TANNERY.

Hereford June 12

Messrs Shead & Son

To C & H Hatton.

F.

To Hair 14 / 4
Do 28 " 11/ 2 2 9
" 11/ 3 5
Contract 8 2

THE WYE BOOT
Light, Waterproof Comfortable

HATTON BROS & C^O
HEREFORD

From

E. C. WITHERSTONE
(Late F. PREECE)

PHOTOGRAPHER

"The Photographic Arcade"

24a, COMMERCIAL STREET,

Every branch of
Photographic work. HEREFORD.

Developing, Printing and Enlarging for Amateurs.

June 2^nd 1939

To R. H. Murray Esq.

Dinmor Manor

N^r Hereford.

March 16^th /38		
Developing 6 - ½ plate & 6 prints	5 - 0	
May 16^th /38		
30 postcards & postage	16 - 8	
Bus fare	1 - 0	
May 20^th /38 4 postcards	2 - 0	
Oct 31^st /38 6 plates	2 - 9	
Nov 2^nd /38 Dev - 2 plates & 2 prints	1 - 8	
" 7^th /38 " 10 " & 10 "	8 - 4	
March 6^th /39 " Postcards	5 - 0	
	£ 2 - 2 - 0	

IMAGES OF ENGLAND

AROUND
HEREFORD

DEREK FOXTON

The
History
Press

This book is dedicated to my wife Maria whom I thank for her patience and understanding while researching and writing this book and to our daughters Dominique and Jessica.

First published in 2006 by Tempus Publishing

Reprinted in 2008 by
The History Press
The Mill, Brimscombe Port,
Stroud, Gloucestershire, GL5 2QG
www.thehistorypress.co.uk

Reprinted 2011, 2012

British Library Cataloguing in Publication Data.
A catalogue record for this book is available from the British Library.

ISBN 978 07524 3828 3

Printed and bound in England.

Contents

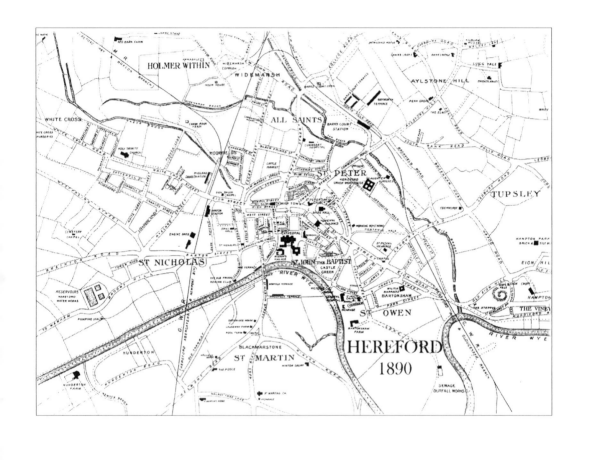

Introduction and Acknowledgements

In compiling this book, I have used two family collections of early photographs. Both collections have never been previously reproduced and provide an insight into Hereford about a hundred years ago. I am most grateful to Mr Eddie Hatton for allowing me to use his family archive of late Victorian pictures. The Hatton family owned The Barton Tannery in Barton Road, where the buildings still survive, also several shops including one in St Peter's Street illustrated in this book on page 13, and a watch and clockmakers shop in Commercial Street. Mr Edwin John Hatton who took these pictures is Mr Eddie Hatton's great-grandfather. He was a very keen photographer and took all his photographs with a plate camera on a mahogany tripod. The most well known member of the family is the artist Brian Hatton who lost his life during the First World War. Many of his numerous paintings and drawings are in the Hereford Museum and Art Gallery.

The Hatton Collection photographs are on pages: 2, 30, 36 *lower*, 37 *lower*, 50, 72, 82 *upper*, 92 *lower*, 93 *lower*, 94 *lower*, 95 *upper*, 96, 97 *lower*, 98, 99 *lower*, 100, 110 *upper*, 113 *lower*, 126 *upper*, 127.

The second archive represents a selection of photographs taken by Mr F. Preece, a professional photographer who had his studio in Commercial Street (see page 28 lower photograph, where the entrance to his business was along an alleyway on the left, near the horse). He produced numerous postcards of Hereford during the Edwardian era, and died in 1928. In 1930 his business and premises 'Byster's Hall' were sold to Mr Witherstone, a First World War veteran and air force photographer. I am most grateful to his descendant Mrs H. Wallace who has allowed me to reproduce the Preece collection.

The Preece collection photographs are on pages: 12 *upper*, 16 *upper*, 17 *upper*, 18 *lower*, 23 *upper*, 25, 26, 27, 28, 32, 33 *upper*, 35 *upper*, 36 *upper*, 40, 41, 42, 43, 44, 45, 46, 48 *lower*, 49 *upper*, 52 *upper*, 66, 67, 68, 69, 70, 71, 74, 81 *upper*, 86 *upper*, 93 *upper*, 94, 95 *lower*, 102 *upper*, 106 *upper*, 108 *upper*, 110 *lower*, 112, 113 *upper*, 114 *lower*, 115 *lower*, 116, 118, 119, 120, 121 *lower*, 122, 123, 124, 124, 126 *lower*.

I am very grateful to Mrs Jean O'Donnell for reading the manuscript and for all her advice; my wife, Maria for reading, editing and correcting the script; Ron Shoesmith

for allowing me to use references from his books, *The Pubs of Hereford City*, and *Hereford History and Guide*; to the Cathedral Library for their help with The Bishop's Palace Chapel, page 46, the Sites and Monuments Records; Herefordshire Council, for the restoration date of Blackfriars Cross on page 31; and Richard Hammonds in association with Herefordshire Council & Art Gallery to reproduce the photograph of the Old Market Hall page 12. Thanks also to Gordon Wood for information from his book *Railways of Hereford* and David Whitehead for references from his book *Historic Parks and Gardens in Herefordshire*. Also to the Pritchard family for permission to reproduce photographs by Walter Pritchard on pages 10 *upper* and 22 *lower* and Ken Edwards for information on the Boy Scouts page 52 *upper*. Finally, to Judith Morgan page 58 *lower* and Margaret Jones page 52 *lower*.

The remaining pictures are from my archive. Wherever possible I have tried to find the copyright holders for permission. I am always interested to hear from readers who have similar photographs and postcards, who may contact me on 01432 357315, or at 4, Helensdale Close, Hereford, HR1 1DP.

Derek Foxton
November 2006

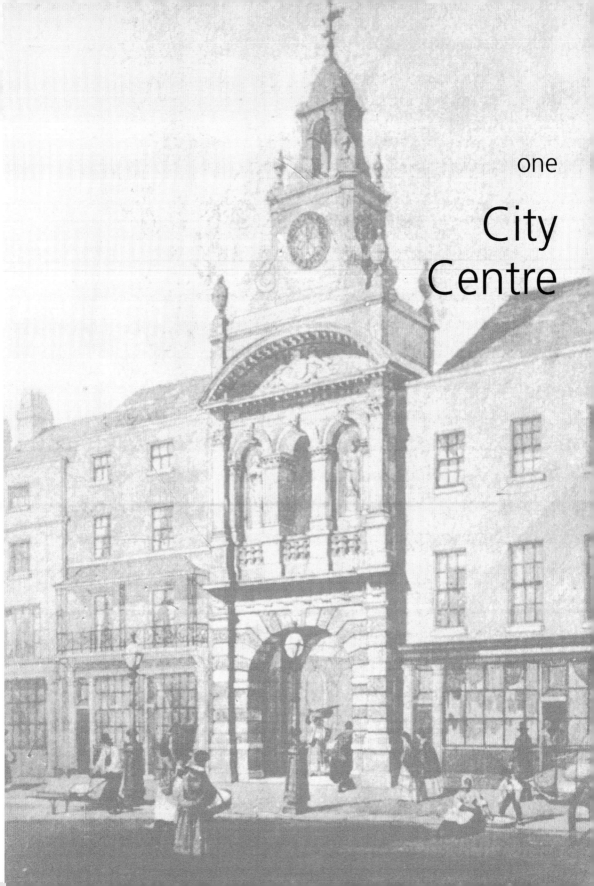

one

City
Centre

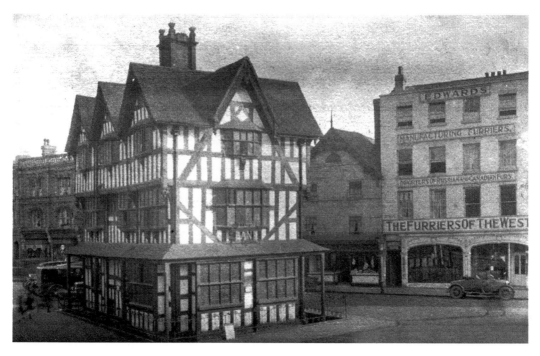

Mr Walter Pritchard took this photograph of the Old House from the upstairs window of his tailor's shop in High Town, *c.*1915. Augustus Edwards' shop is in the background.

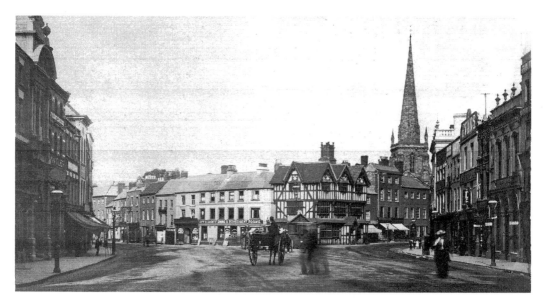

Above: This is High Town around 1895 showing the Old House built in 1621. On the left is the Butter Market that was opened in 1862 and on the right is St Peter's church.

Opposite below: Butchers John and Mary Jones were the first known occupants of the Old House (built in 1621). The fine carved wood bargeboards and bunches of grapes are visible. The owner's name, Smith, is visible above his saddler's shop entrance. He occupied the building from 1868 to 1870.

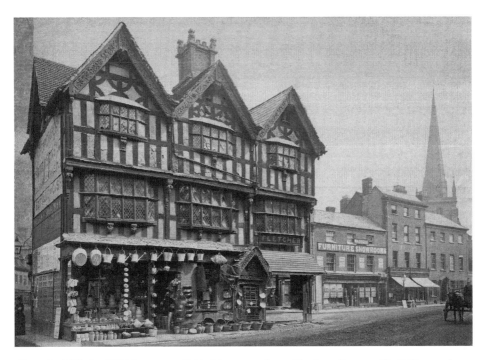

Above: In 1879 the Old House was divided into two shops. Matthew Curnow Oatfield owned the shop on the left where he sold glass, china and hardware, while on the right William Henry Fletcher sold fish. In the background is Maddox furniture showroom with rolls of linoleum and carpets in the entrance.

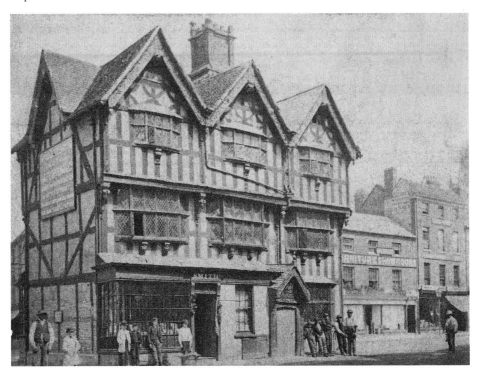

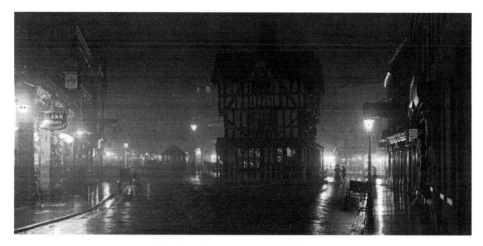

This rare gaslit photograph of St Peter's Street and the Old House is an insight into early evening activities in High Town. The time on the Market Hall clock shows 6.45 p.m. High up on the left is the illuminated Elephant & Castle pub sign, where the proprietor was Mrs Lloyd. The pub stood behind a draper's shop and was approached along an alleyway. Opposite is Lloyds Bank (The Old House) whose manager was Thomas Williams Allen.

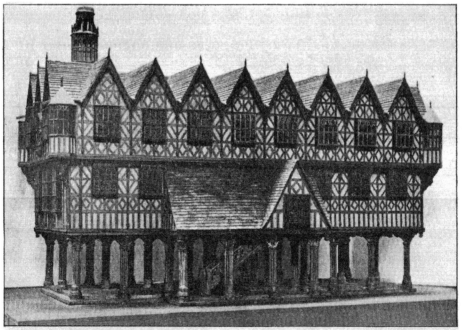

The Old Town Hall, Hereford, demolished 1861. *Model by Mr. L. J. Starkey, in Hereford Museum*

Hereford has had a central market area since Norman times. This magnificent timber-framed Old Market Hall, built around 1580, stood in the centre of High Town. Historian Sir Nicholas Pevsner described it as, 'the most fantastic timber-framed building imaginable'. The upper floor was removed in 1792 and the whole building was demolished in 1861-62. This model in the museum shows how it looked before the alteration.

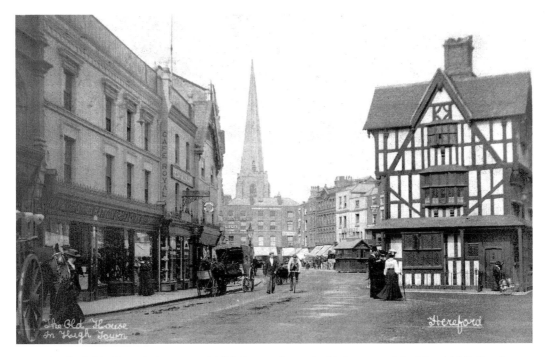

On the left is Hatton's shop around 1905, boot maker and athletic store at Nos 14 and 15 St Peter's Street. There is an unusual amount of activity with pedestrians, horse-drawn delivery carts, handcarts, a motorcar and cyclist. Mr Hatton took many of the pictures in this book.

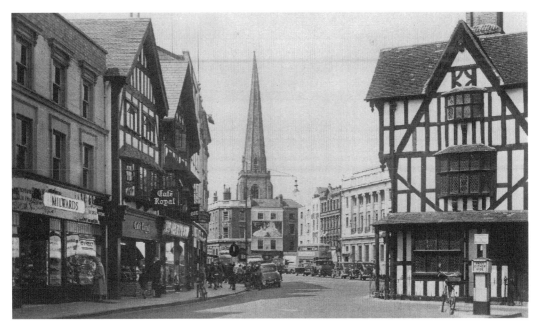

The Old House is shown in pristine condition, c. 1950. The shop with the large advertisement is Marchants, a dispensing chemist. It was demolished to make way for the Midland Bank's extension soon after the photograph was taken. The half-timbered front on the Café Royal is new.

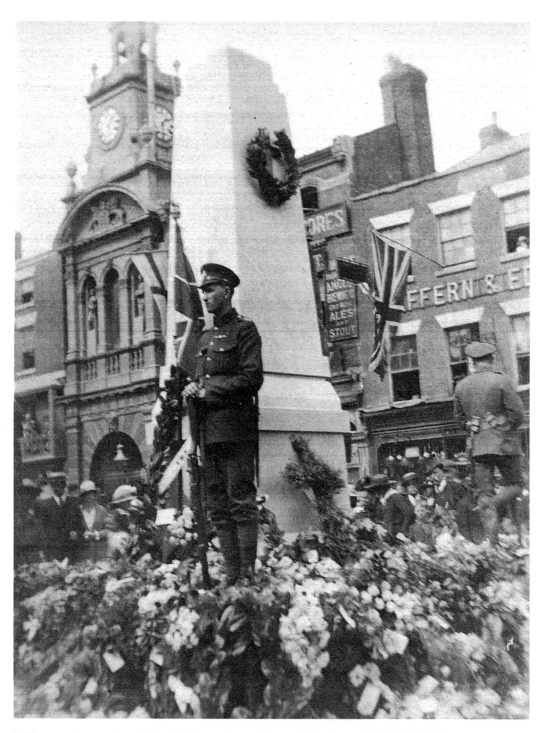

Soldiers stand to attention during the Remembrance Day service in front of the Market Hall. In 1919, after the end of the First World War, Hereford did not have a war memorial, so the council constructed a temporary wooden one while they made plans for a permanent stone cross. This was later erected in St Peter's Square (see opposite page).

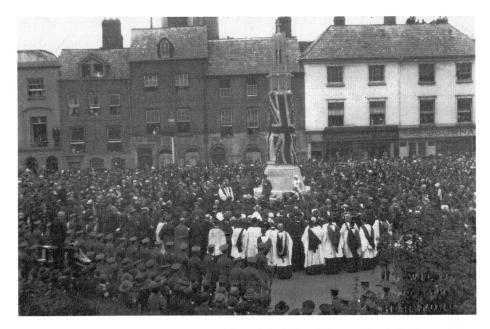

The Hereford City and County war memorial stands in St Peter's Square. The dedication and unveiling service took place on Remembrance Sunday 1922. The memorial is in the form of an Eleanor Cross, originating from 1290 AD and named after Edward I's queen. The cross is octagonal with eight panels. One is inscribed, 'To the Men of Herefordshire who fell in the Great War 1914-19'. There are four figures: soldier, airman, sailor and nurse. Crowning the whole is a dome from which rises a foliated Latin cross. Designed by Mr Barnard of Cheltenham, it is 30ft 3in high. Note the nurse standing on the base below the union flag.

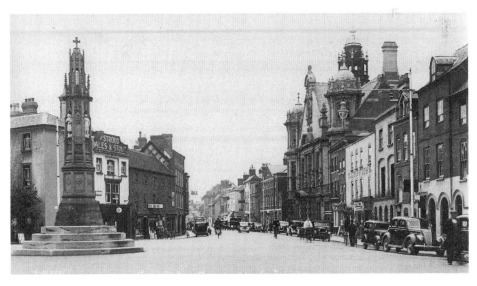

The St Peter's Square war memorial guards the entrance into St Owen's Street. T. Griffith, a grocer who had three shops in the city, has painted his name on the wall. H.A. Cheers, a Twickenham architect, designed the Town Hall, which cost £25,000 and took two years to build. It was opened on 9 June 1904. On the opposite side of the road is the Golden Fleece.

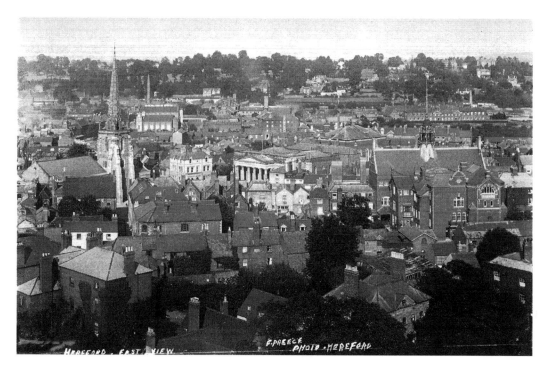

HEREFORD . EAST VIEW F.PREECE PHOTO . HEREFORD

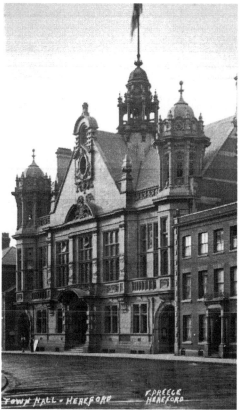

TOWN HALL . HEREFORD F.PREECE HEREFORD

Above: The top of the Cathedral Tower is a panoramic viewpoint. The Shire Hall with its Corinthian columns is in the middle of this photograph with St Peter's church to its left and the Town Hall to the right. On the lower right is Harley House built with stones from the ruined Cathedral Chapter House. Aylestone Hill is in the distance.

Left: Architect H.A. Cheers of Twickenham designed the Town Hall in late Victorian times. HRH Princess Henry of Battenburg laid the foundation stone on 13 May 1902. The City Plate and Charters are kept here in a basement strong room and include the famous charter granted by Henry III, in 1227, to hold a fair on the Feast of St Denis and the two following days. The previous Town Hall which had stood on wooden columns in High Town was dismantled in 1861-62. (See page 12 *lower*)

Opposite below: The Green Dragon Hotel is the city's premier hotel and coaching inn. On the right is the horse-drawn Green Dragon carriage that took clients to and from the railway station. Three soldiers attend the military gun carriage drawn by the four horses. The other soldiers wait outside the hotel entrance. This 1913 postcard has no information about this occasion.

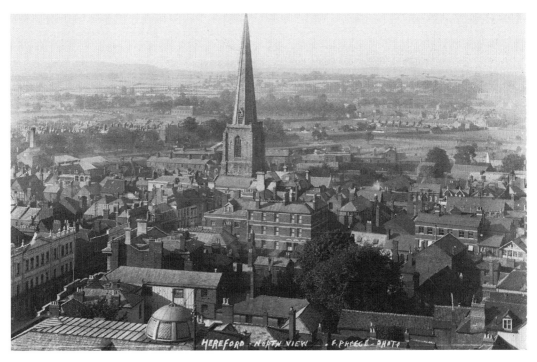

Above: The 220ft-high spire of All Saints church, which is the tallest in the county, dominates this view from the top of the Cathedral Tower. To the left is Broad Street and the Green Dragon Hotel. The large chimney seen above the Green Dragon Hotel is the Hereford Brewery which was owned by the Watkins family. The dome is the roof of St Francis Xavier's church. Below All Saints tower is the City Arms Hotel built in 1791 by the 11th Duke of Norfolk. The distant large building to the left of the steeple base is the Hay & Brecon Railway engine shed.

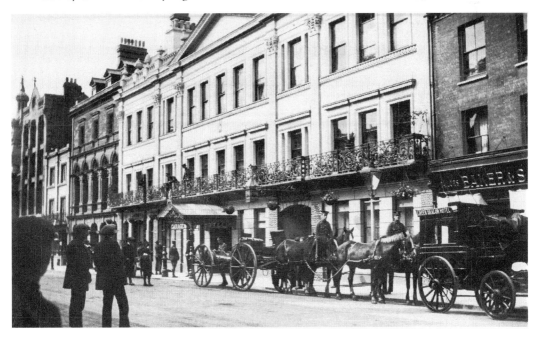

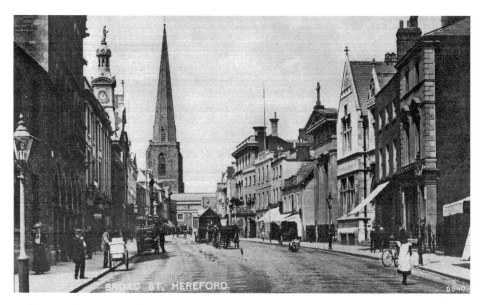

In this Broad Street scene from around 1906, the building on the extreme left, 'Residence House', is a canon's home that belongs to the Cathedral. The Kemble Theatre with the clock tower and statue is next to the Hop Market. In the centre of the street is a cabbie's rest hut with a horse-drawn cab waiting for a fare. Note on the right edge the closed gates into the Cathedral Close.

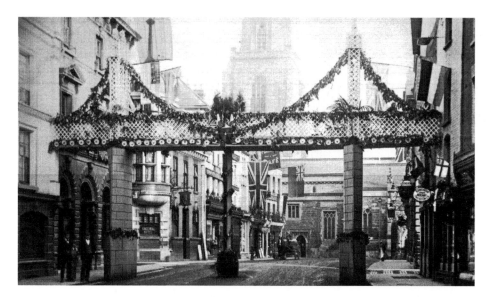

The historic Three Choirs Festival is held in rotation in the three Cathedral cities of Worcester, Gloucester and Hereford. The date of the first meeting is unknown but the first recorded festival in Worcester was 1719. During the Three Choirs Festival week, Hereford became a blaze of flags and arches built across several streets. This is the 1906 celebration archway erected in Broad Street. At night, temporary oil lamps at the base of the central column illuminated it. The design of the arch was supposed to resemble the recently opened Victoria Bridge. Just behind this archway is the round turret of the King's Head Hotel. The building on the extreme left is Arnold Perrett's Wine Vaults, with Barclays Bank behind the two men. The huge Union Jack hangs outside Heins Music Shop.

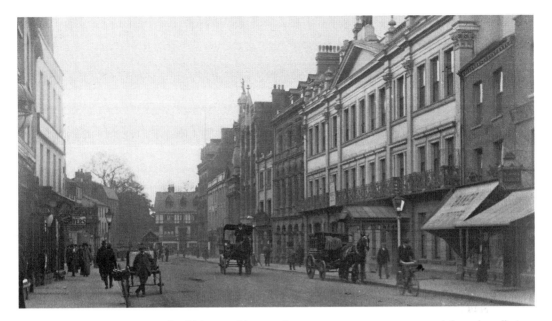

There are no motorcars; all vehicles are either one horsepower or one manpower and the only pollution is the manure. In the distance, just past the Green Dragon Hotel, is the statue on top of the Kemble Theatre.

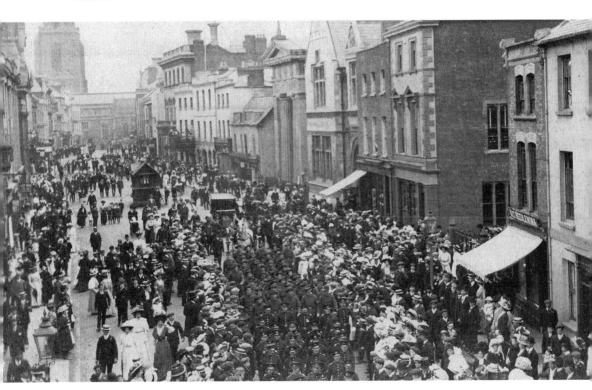

The Territorial Army are on their way to the Cathedral, marching along Broad Street on 27 June 1909. The shop on the right with the sun awning is 'Art and Needlework' owned by Miss Stalman.

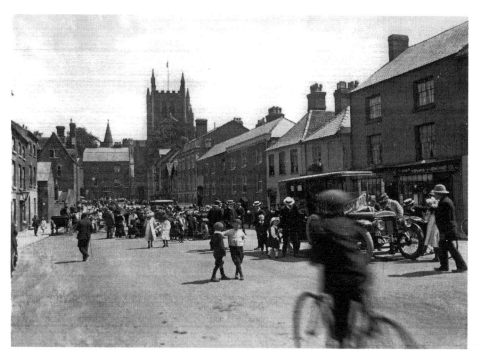

Above: In 1911 Prince Heinrich (Henry) of Prussia, brother to Kaiser Wilheim 11 of Germany, took part in an international two-part motorcar trial driving a Benz car. The first part was held in Germany and the last was in this country. They left Shrewsbury on Tuesday 18 July 1911, stopped for lunch in Hereford and then went on their way to Cheltenham for the night. Here they are in King Street just before departure with the official car at the front.

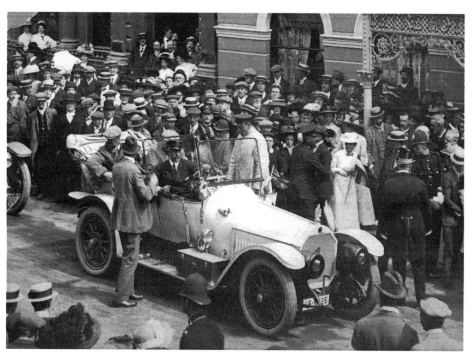

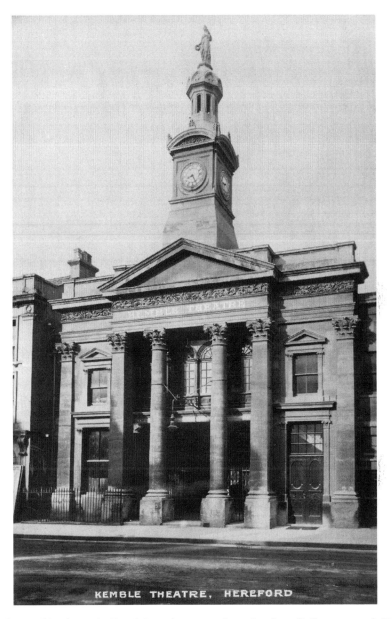

KEMBLE THEATRE, HEREFORD

Above: The Kemble Theatre in Broad Street has a most imposing front. Built at a cost of £3,580 in 1857 as the Corn Exchange, it was enlarged in 1911 with the addition of a public hall and theatre for £5,000.

Opposite below: Prince Heinrich sits in the driver's seat of his Benz motorcar outside the Mitre Hotel, Broad Street, waiting to leave for Cheltenham during the Prince Henry Car Trial. The woman in the white dress holding a flag is Miss Maud Bull. There were fifty German entrants and fifty British, entered by the RAC. A condition of entry was that each car had comfortable seating for four adults and was owned by the entrant. The entry fee of 40 guineas included the channel crossing. The competition was a reliability trial, with each car carrying an observer. The bonnet was sealed and servicing was allowed for only half an hour each morning before the start.

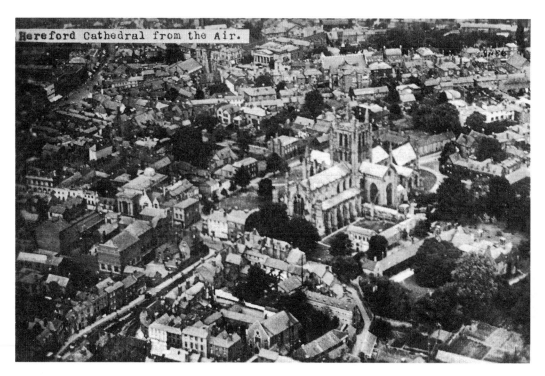

Early aerial photographs of Hereford are rare. The houses in front of the Cathedral facing King Street were demolished around 1935. Part of Gwynne Street is visible in the centre, just below the Cathedral. Note the Wesleyan Methodist chapel, near the lower edge, which stands behind the Bridge Street line of buildings.

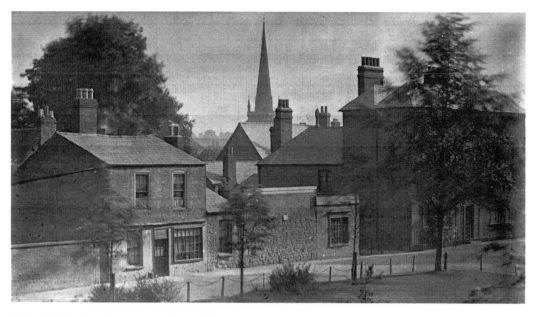

Walter Pritchard took this unusual view of the Green Keeper's Cottage, on the north side of the Cathedral Close, from his bedroom window. Pritchard's house stood in front of the Cathedral in Broad Street, facing King Street (see page 23 *lower*). The entrance to Church Street is near the tall tree.

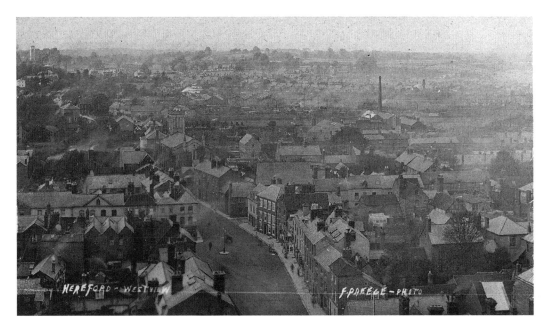

This King Street view was taken from the top of the Cathedral Tower. At the top of Bridge Street, near the lamppost and mini roundabout, is the Orange Tree public house. Just two shops towards the Cathedral is Ladmore's garage with its petrol pumps. The petrol was stored in the cellar! Ladmore was also a gun maker and photographer. St Nicholas church is near the centre of the photograph, while at the top left corner is the Water Tower. The Drill Hall in Friar Street is the large building to the right of the church. Nearby is the Watkin's Flour Mill's chimney.

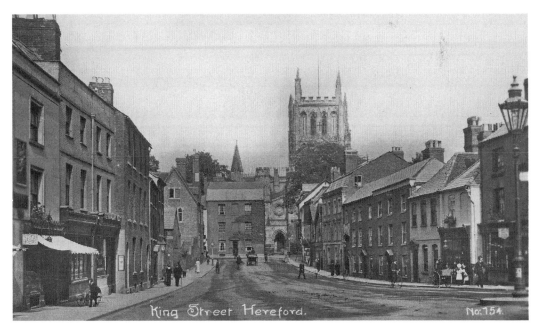

The Cathedral forms the background to this 1919 King Street view. After a fire in 1935, the houses in front of the Cathedral were demolished.

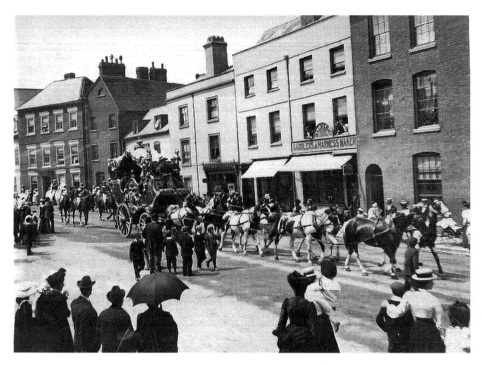

Above: In 1899 the circus arrived in town and promoted their visit with a grand parade. This view along King Street is of the golden 'State Coach' pulled by six horses. In the background is Walker, the saddler & harness maker's shop managed by R.E. Enoch.

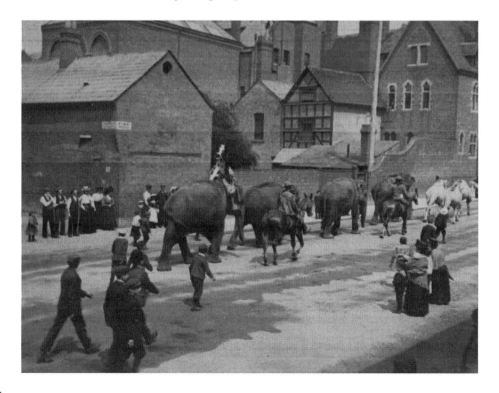

Right: The timber-framed Old Market Hall (see page 12 *lower*) built around 1580, stood in the middle of High Town until demolition in 1861–62. The City Corporation had a competition to design a new Market Hall entrance that leads into the market area behind the shops. It was won by Clayton, an architect.

Below: A sign for Lloyd's Bank can be seen on the side of the Old House in this gas-illuminated photograph from around 1905. The Hereford May Fair was originally the Fair of St Ethelbert, a right granted by King Henry I to the Bishop of Hereford. In those days, the Bishop held the keys of the city, received the tolls from all imports, held courts and inflicted punishments within the precincts. This caused frequent conflict between the Bishop and the citizens. The Cathedral canons received 10 per cent of the profits from the fair. In 1838 an Act of Parliament took away the Bishop's privileges and granted him compensation of 12½ bushels of wheat or the equivalent in monetary value, and limited the fair to three days. *(Jakeman & Carver* 1914). The roundabouts were steam driven and electric light was generated by traction engines.

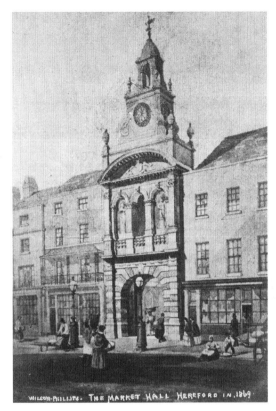

WILSON-PHILLIPS. THE MARKET HALL HEREFORD IN 1869

Opposite below: The arrival of the circus in 1899 was a great occasion for the children who were able to see this parade of exotic animals including elephants and camels. The building in the background is the City Museum and Art Gallery, while the stables and coach house belonged to the Residence House, Broad Street. This was the home of Revd Charles Samuel Palmer, canon residentiary of the Cathedral.

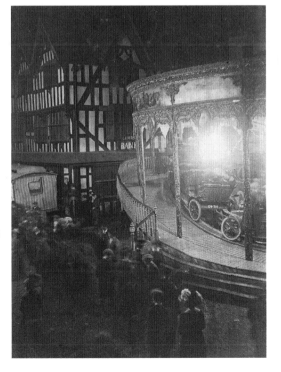

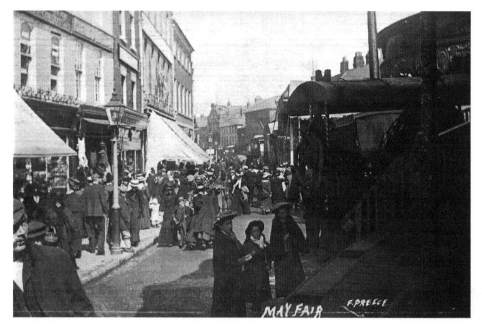

The buildings to the right of the lamppost are in Commercial Street while those to the left are in High Town. In 1907 the shop on the left was Lismore & Son, china dealers, with Cresswell, a butcher, next door. Both had a High Town address. The shop to the right of the lamppost was Pritchards, a tailor. On the rear of the traction engine is a large pipe for connecting to a water supply.

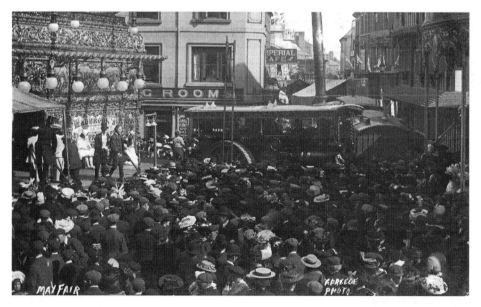

The traction engine was an essential part of the travelling fair. Used to tow all the heavy roundabouts around the country, at the showground it generated electricity or a provided a direct belt drive. It was also a showpiece in its own right with its polished brass and bright paint. The City & County Dining Rooms are in the background where the resident owner was Henry Jones. Wadbrook's 20th Century Electric Light Show is on the left.

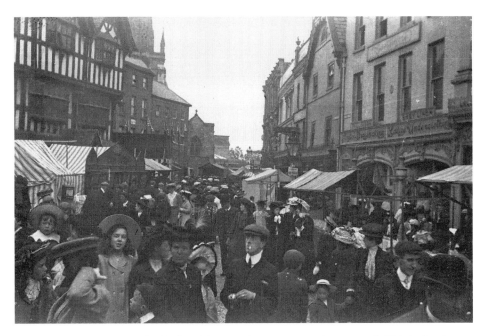

The Hereford May Fair is a highlight of the year that attracts very large crowds. This is the view from High Town through St Peter's Street towards St Peter's church showing small stalls and amusement tents. The shop on the right is Augustus Edwards, a silk mercer, draper and furrier. The entrance to the Booth Hall passageway is just visible to the left of his shop.

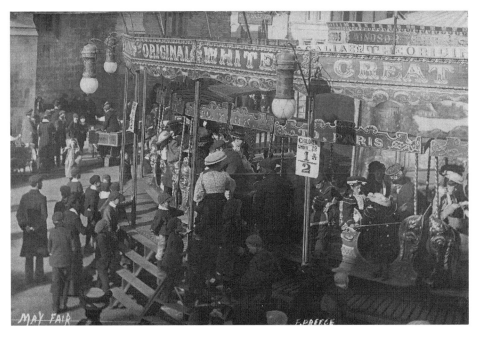

This picture of the May Fair around 1905 in St Peter's Square was taken from an upstairs window in Pullin's wine and spirits shop. The price of a ride for children under twelve was a halfpenny. Note the group of children on the left watching attentively as they wait for the next ride.

Aylestone Hill is on the main road from Hereford to Worcester. This quiet Sunday view looks from the city towards the summit and junction with Folly Lane. The metal railings to the right belong to 'St Hilda's'. Hidden behind the hedge on the left is Penn Grove House, now renamed Churchill House, which had a 20 acre estate that extended as far as College Road.

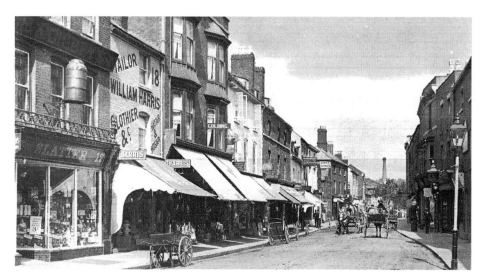

All along Commercial Street, the handcarts are ready to deliver and collect goods. The distant chimney belonged to Monkmoor Mills, near the station. The giant milk churn hangs outside Slatter's grocery shop. This business name survived in the city for over eighty years. Two doors away a copper kettle hangs from Golding's hardware shop. William Harris has used the whole of the upstairs façade of his premises to advertise this business. The other shops past Goldings are: Davis & Son, dyers; Tucker, photographer, Rosser, butchers; and Francis Preece, photographer. It was Preece and his successor Witherstone who took many of the pictures in this book. Many of the south-facing shop fronts have sunblinds to protect the window displays from the sun.

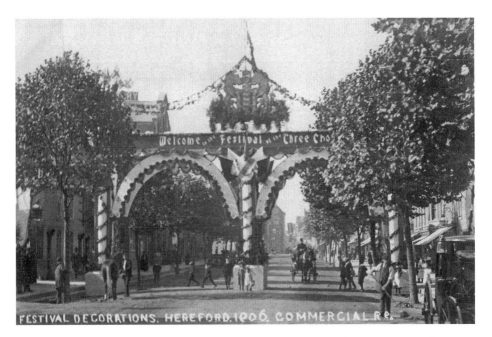

The huge decorative arch on Commercial Road celebrates the 1906 Three Choirs Festival in Hereford. Greenland's Depository and warehouse is the tall building on the left. On the opposite side of the road is the entrance to Monkmoor Street. Note the double steps up to the pavement.

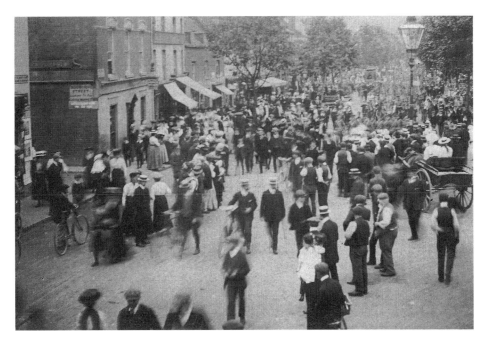

The crowds watch a military parade marching along Commercial Road towards the photographer who is in The Kerry Arms, *c.* 1905. It appears that the parade will turn to their left, into Bath Street. To the left is the entrance into Blueschool Street. The photographer used a long time exposure to take this photograph.

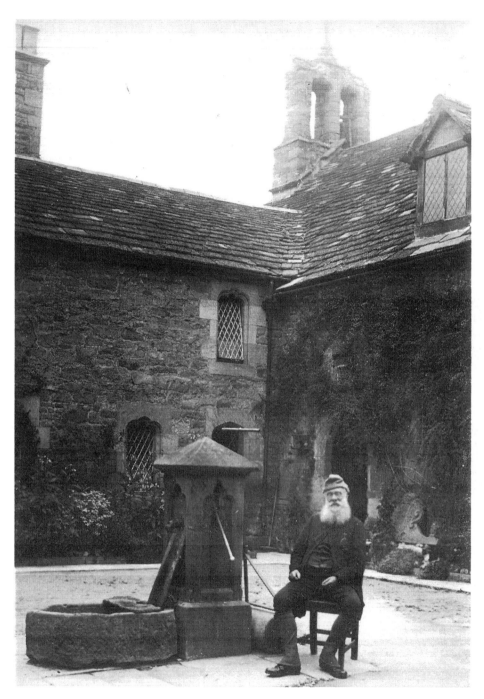

Coningsby Hospital, Widemarsh Street, was originally called the Red Coat Hospital after the residents who wore red coats. Built in 1614 by Sir Thomas Coningsby of Hampton Court, it incorporated part of the thirteeth-century house of the knights of St John of Jerusalem. This view of the courtyard from around 1890 shows a seated resident pensioner next to the water pump. He is wearing his Coningsby Conies (Rabbits badge). Residents lived in the twelve almshouses and were allowed to marry.

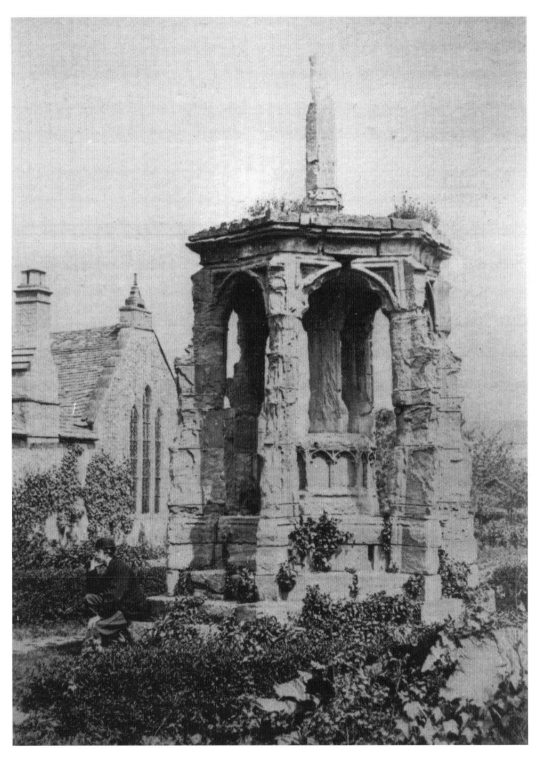

This is a rare and very early photograph of the Blackfriars Preaching Cross, Widemarsh Street. It was taken before Sir George Gilbert Scott's 1863 restoration.

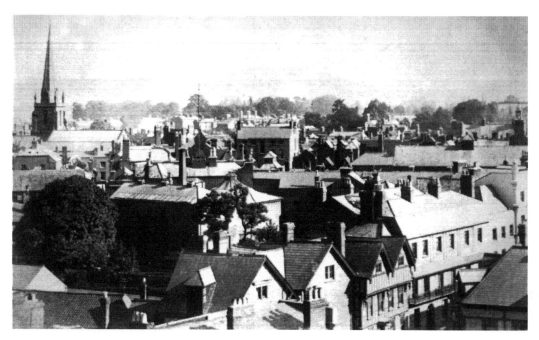

Above: This bird's eye view is taken from the top of the Electricity Works chimney in Widemarsh Street, *c.* 1910. The Wellington Hotel is on the lower right corner, where Henry Tipping was the owner. The black and white house was occupied by Ernest Davies, an architect and surveyor; Cumming E. Knowles, a solicitor; the London and Lancashire Fire Insurance Co.; and Cecil Price, the resident secretary. Just behind are the extensive buildings of the *Hereford Times* printing works. The Butter Market clock tower is on the right edge, while to the far left is St Peter's church spire.

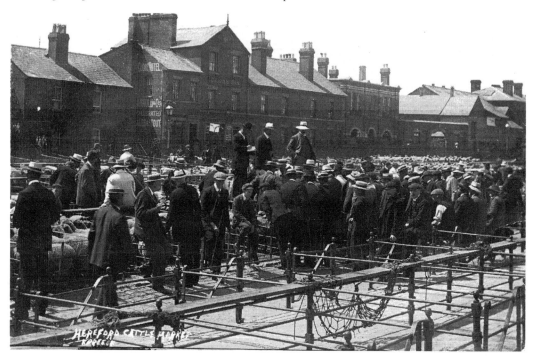

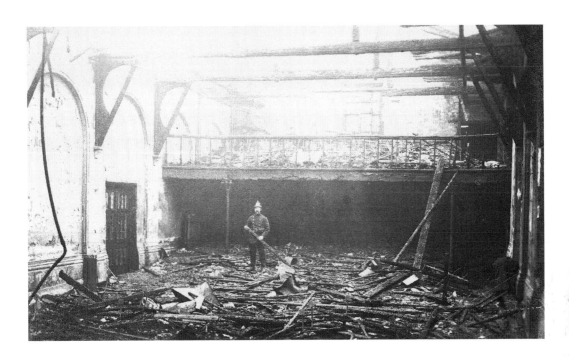

Above and right: The Garrick Theatre caught fire on Friday 7 April 1916. It started during a charity performance and took the lives of eight local children taking part in a concert. In 1882 this was the site of the Foresters Hall, then by 1886 it had become the Volunteer Drill Hall. In 1895 it was the Athenaeum Theatre and then around 1900 it was renamed The Theatre Royal. By 1909 it was called the Garrick Theatre (see page 52 *lower*).

Opposite below: Wednesday is market day in Hereford. The auctioneer and his assistants on their platform are auctioning sheep. The buildings in Newmarket Street look as if they are part of the market. The Globe Inn and Hotel (behind the auctioneer) which occupied a 32-square-yard plot and backed on to Wall Street, opened before 1872 and closed on 30 September 1932 (Shoesmith – *The Pubs of Hereford City*). To the right of the auctioneers is the Wheatsheaf with its stable block.

THE NEW

GARRICK THEATRE

 WIDEMARSH STREET,
· · HEREFORD. · ·

The Most Up-to-date Theatre in the West of England.

Proprietor and General Manager	:	:	:	REGINALD A. MADDOX.
Assistant Manager :	:	:	: : :	STANLEY BAXTER.
Telephone 1186.		Telegrams—"Maddox, Hereford."		

 PICTURES,
VARIETIES,
COMEDIES,
AND
DRAMA.

Patronised by the Elite of City and County.

POPULAR PRICES.

7 : Twice Nightly : 9

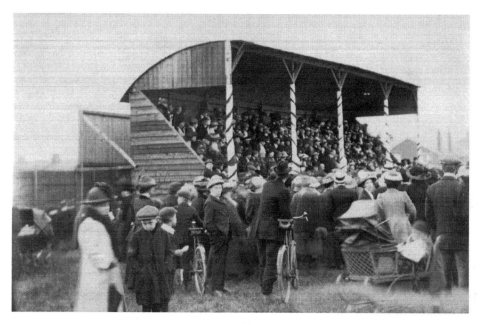

The Hereford United Football Ground is the scene of an unknown event, *c.* 1920. The crowd in the grandstand have a good view while those on the football pitch look over the shoulders of those in front. Note the wicker pram.

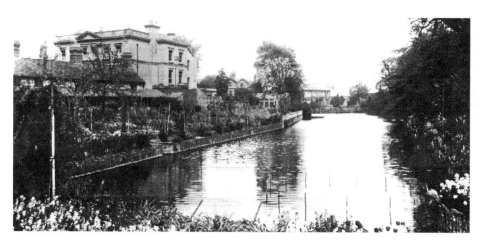

Above: The Castle Pool is the last remaining length of the Hereford castle moat. The houses in the distance are in St Ethelbert Street with the Castle Pool Hotel towering above the St Ethelbert Almshouses, which were founded in 1240 by the Dean and Chapter for ten ancient and poor people. The residents had to attend the Cathedral daily unless hindered by sickness. The almshouses in this picture were built in 1805 with some of the stone taken from the ruined Cathedral Chapter House.

Opposite below: These Hereford cattle are on their way to the market in Broad Street. This is one of the earliest photographs of Hereford taken at the junction of Eign Street, Victoria Street and Edgar Street, *c.* 1850. The entrance into Edgar Street is to the left. The Victoria Wine and Spirit Vaults later replaced the derelict building. The triple-gable ended building on the right is the Maidenhead Inn.

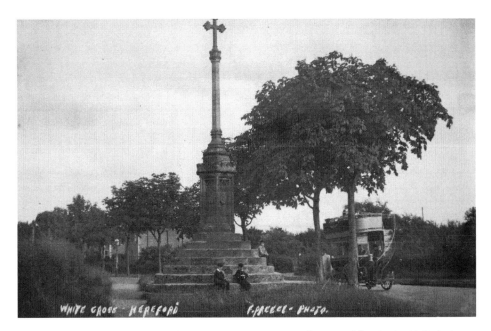

WHITE CROSS · HEREFORD · F.PACKER · PHOTO.

Above: Bishop Charlton erected Whitecross monument one mile west of the city in 1362, during the second outbreak of the plague. This was a temporary market site where the farmers could bring their produce for the inhabitants of the city and not come in contact with the disease. The monument pedestal and its steps are original but the shaft and cross were added during restoration in 1564. The horse-drawn omnibus seated sixteen on the upper deck and plied between the railway station and Whitecross via High Town.

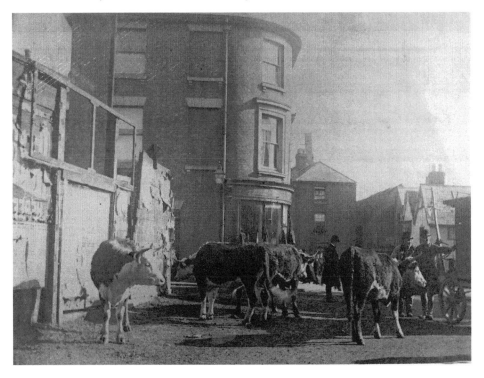

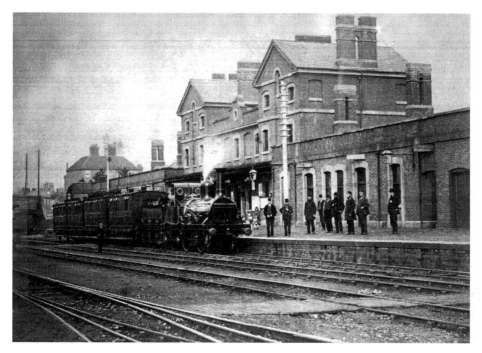

The first railway station at Barton was a temporary building that opened in 1853. In 1856 the architect Clayton designed a permanent station, at the time described as austere and institutional. In 1877 the platform was extended so that it was over 1,000ft long and 37ft wide. Some station staff and railway workers are looking at the photographer. Sainsbury's and The Railway Club now occupy the site. (Gordon Wood – *Railways of Hereford*)

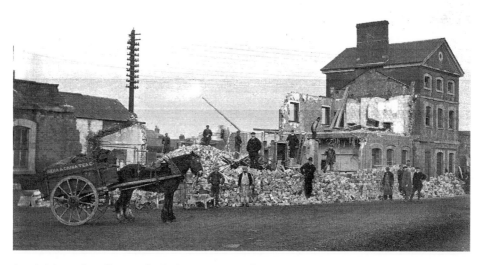

A sad sight to the railway enthusiast's eyes in 1893, the main Barton railway station has almost gone. The India & China Tea Co.'s horse-drawn cart has arrived to take some bricks to their head office at Clarence House, West Street. All work has stopped for photographer Hatton to take his photograph.

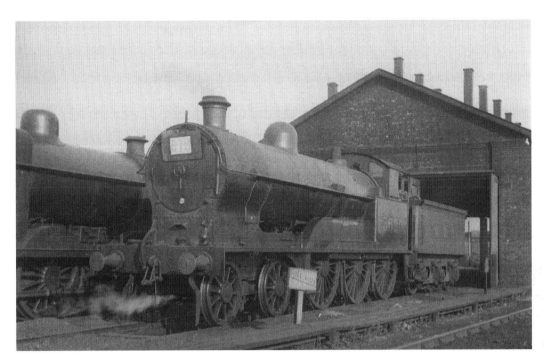

Written on the reverse of this postcard is, 'locomotive 5620 at Hereford L.M.S. shed', dated 10 May 1937, and signed by A.C. Roberts. The small sign shows the track gradient at the Barton locomotive shed.

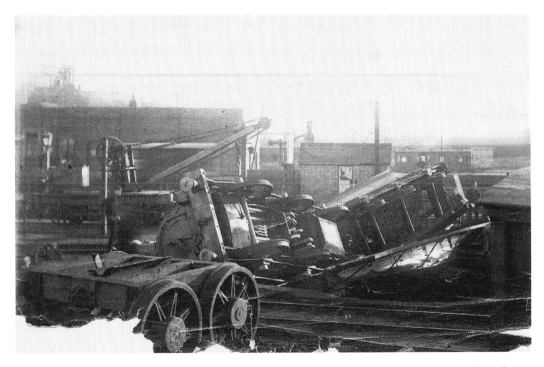

The railway accident happened on a turntable in Barton railway station goods yard, *c.* 1895. The railway wagon crane does not look strong enough to lift the upturned locomotive.

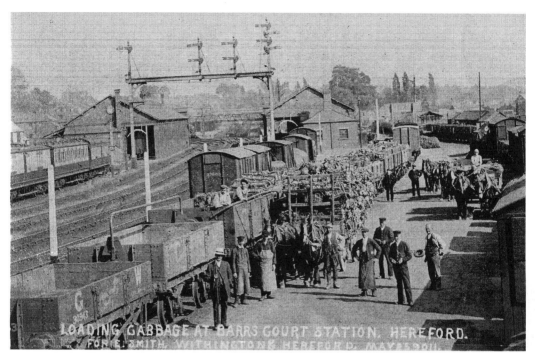

Above: At Barrs Court railway station goods yard on 25 May 1911, local cabbages from Withington are being loaded at the railway sidings, north of the railway station. Every person in the sidings has posed for the photographer who is on the Newtown Road railway bridge.

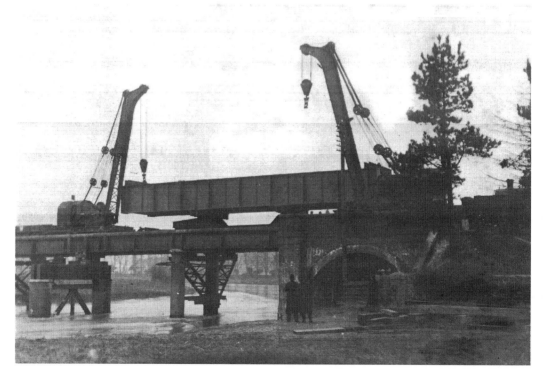

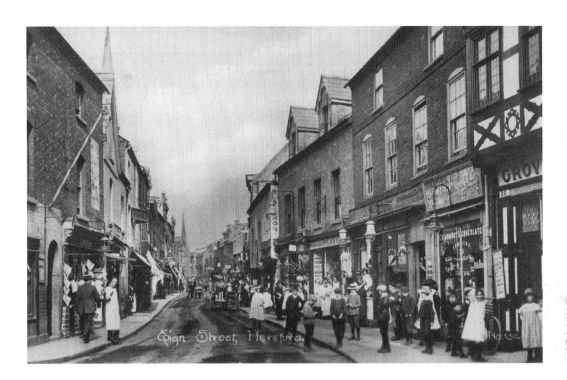

Above: This is Eign Street with the spire of All Saint's church on the left and St Peter's church spire in the distance, *c.* 1905. The vertical shop sign in the middle reads 'Blackmon' who traded as a grocer. The timber-framed building on the right is the Maidenhead Inn.

Right: This off-focus view of Eign Street features a hand delivery cart and All Saints church spire. No.76 is Half Moon Inn of the Hereford and Tredegar Brewery.

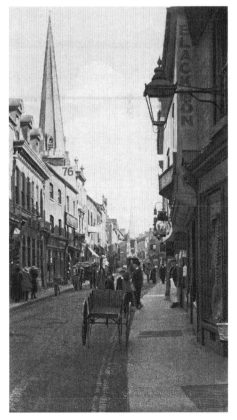

Opposite below: The Hereford Ross & Gloucester railway crossed the river Wye near the Salmon Inn, Hampton Park Road. The first bridge, designed by Brunel, was wooden with a broad-gauge track nailed to the timber beams. To build the second bridge in 1865, dams were constructed in the river to enable construction of the piers to proceed. The steel bridge is described as having little architectural beauty to commend it. It rested on two sets of triple-iron cylinders filled with concrete. This design provided little resistance to flood water. In 1931 the bridge was rebuilt to a higher specification to take heavier loads. Floods interfered with building progress. The new bridge had a central pier with massive 83ft-long girders weighing 160 tons which were moved by steam crane as seen here. Traction engines on the banks pulled down the old piers with block and tackle. (Gordon Wood – *Railways of Hereford*)

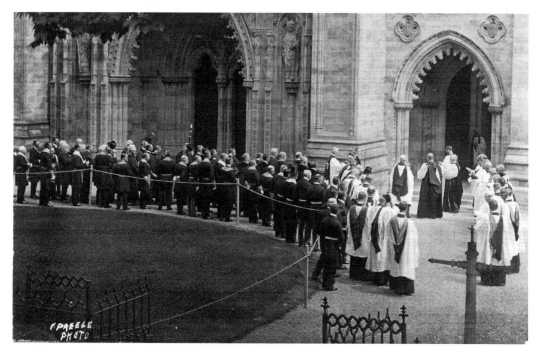

The new Cathedral west front was the backdrop for its dedication service in June 1908. The bishop, dean, chapter, other clergy and visiting bishops have assembled to greet the procession. There were bishops and representatives from Carpentaria, Melbourne and North Carolina. The City Sword held by the City Sword Bearer is visible above the crowd. The mayor was Cllr Edward F. Bulmer (1908-09). The Cathedral Close then had a gate and heavy iron railings, which are visible.

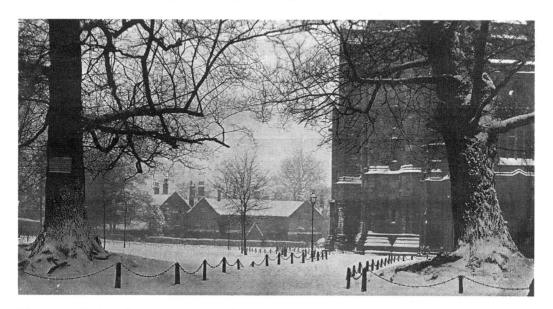

The snow is 9in deep, the temperature below freezing and no one is in sight. The Cathedral north porch entrance is behind the tree on the right. The whole of the Close is an ancient burial ground. The distant building is the Deanery.

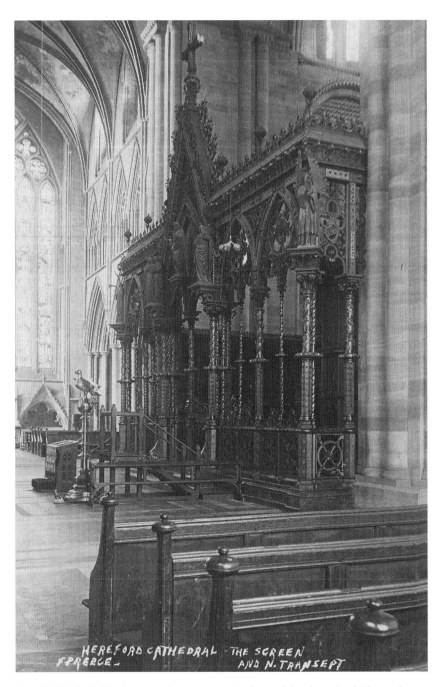

HEREFORD CATHEDRAL - THE SCREEN
F PIERCE - AND N. TRANSEPT

Hereford Cathedral had a wrought-iron screen in front of the chancel, which stood between the eastern pillars of the tower. It was an elaborate example of artistic metalwork made by Francis Skidmore of Coventry from designs by Sir George Gilbert Scott. Completed and exhibited at the International Exhibition of 1862, the *London Illustrated News* hailed it as, 'the grandest most triumphant achievement of modern architectural art'. The screen, installed in 1863, was a mixture of gilded and painted ironwork, brass, copper and mosaic. It is now displayed in the V&A, London.

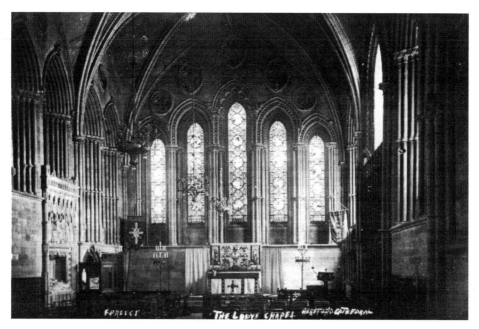

Above: The lady chapel at the east end of the Cathedral dates from 1196 to 1225. It has a crypt that is 56ft long by 31ft wide that is approached by five steps. On the east wall there is a window made in the London studio of Charles Gibbs which depicts scenes from the life of Jesus.

In the carved roundel above the central window is the figure of a standing bishop. There are two monuments visible in the north wall; nearest is a rectangular altar tomb with an effigy of Peter de Grandison, who died in the mid-fourteenth century, with an effigy of Joan de Bohun around 1327 set nearby on the wall. In the south wall is the entrance to the Audley chapel with its ornate screen. The window, designed by N.J. Cottingham, is a memorial to Dean Merewether.

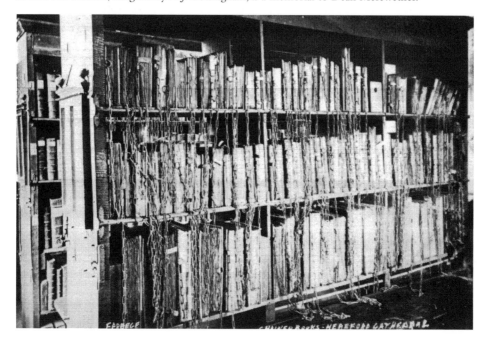

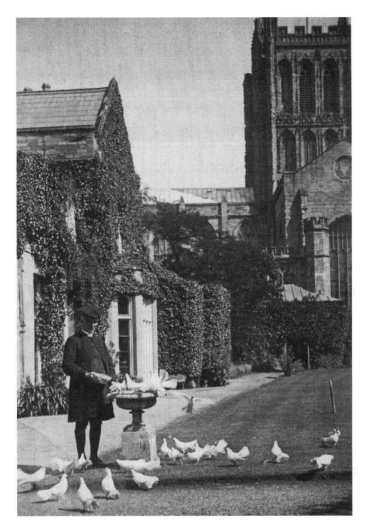

Above: The Bishop of Hereford, the Right Revd John Percival, attends his flock of doves during the summer of 1914. There are twenty-one birds including one in flight. His garden overlooks the river. Behind him is the Palace, one of the oldest timber-framed secular buildings in England, built around 1185 as a great hall. About three quarters of it survives, hidden inside the present building. In the background is the south side of the Cathedral.

Opposite below: The books in Hereford Cathedral chained library were originally stored in wooden chests. They were handwritten on vellum and highly treasured. In 1590 the books were kept in the lady chapel and then in 1611 Richard Rogers of Hereford introduced the stall system which had ironwork and chains made in Oxford. The chains were an early form of security, ensuring that the readers could read the books in situ but not remove them. In 1855 some of the cases were moved into a room over the north transept aisle. In 1897 the remaining part of the library was installed in the newly built Dean Leigh building. The chained library is the largest in the world and comprises around 2,000 books. Among the treasures of the library are Caxton's first edition of the *Golden Legend* (1483) and *Wycliff's Bible*, written around 1420. Among the finest gems of the collection is the Anglo-Saxon manuscript of the Latin Gospels, bequeathed by Athelstan, the last Saxon bishop of the see in 1056.

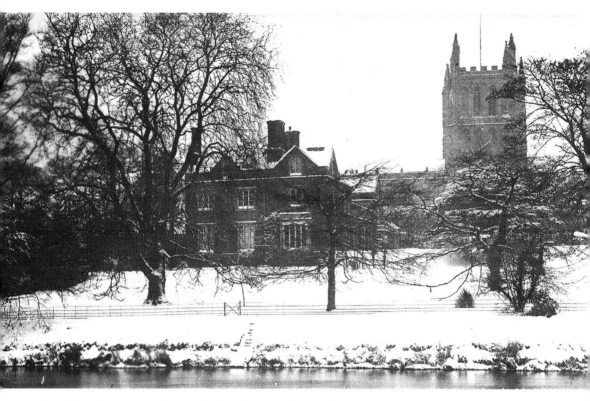

Above: 9ins of snow cover the steps leading down to the river from the Bishop's Palace. Bishop Blisse constructed the Palace wing facing the river as part of major alterations during his term of office 1713-21.

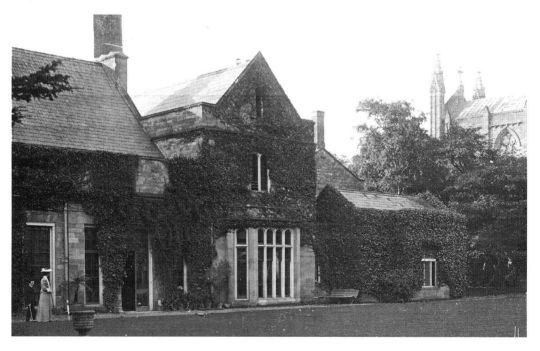

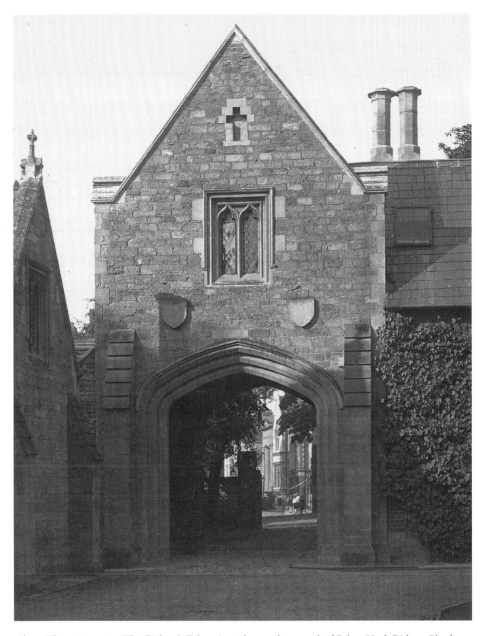

Above: The entrance to The Bishop's Palace is at the southern end of Palace Yard. Bishop Charles Booth (1516–35), the last pre-Reformation bishop of Hereford, who made considerable alterations to the Palace that involved building the northern range to accommodate the new kitchens, built this gateway with massive wooden doors. Broad Street is through the archway.

Opposite below: The Bishop's Palace garden extends down to the river Wye and north to the south wall of the Cathedral. The recently rebuilt west front of the Cathedral is on the right of this photograph taken around 1910. Bishop Philip Blisse built the gable end during his occupation. Sadly, it replaced one quarter of the timber-framed Norman great hall. To the left, behind the elegant woman is the garden entrance into the great hall.

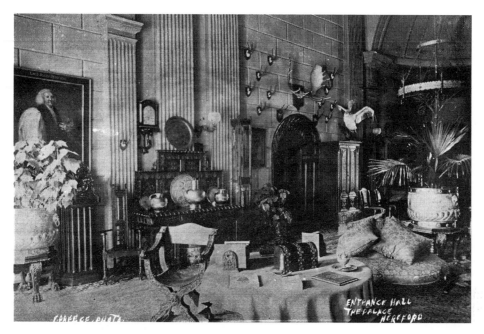

This photograph of the entrance hall into the Bishop's Palace was taken during Bishop John Percival's term of office (1895–1917). It was built within a late Norman timber-framed great hall. Bishop Philip Bliss (1713–21) remodelled and divided the original hall into five rooms. The new hall extends across the building from the front entrance to the back garden. The Bishop's Palace is unusual in that it does not have a grand staircase.

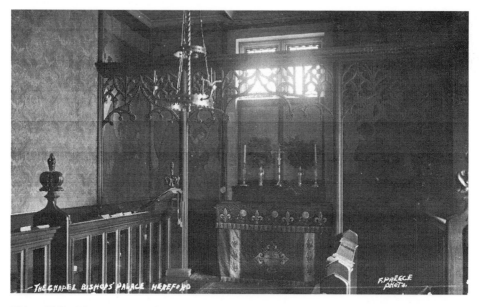

Bishop Philip Blisse (1713–21) built the original Bishop's private chapel inside the timber-framed Norman great hall. By 1870 it had been demolished and replaced by this chapel built on to the north end of the Palace, which was described as small and plain with murals that are just visible in this picture.

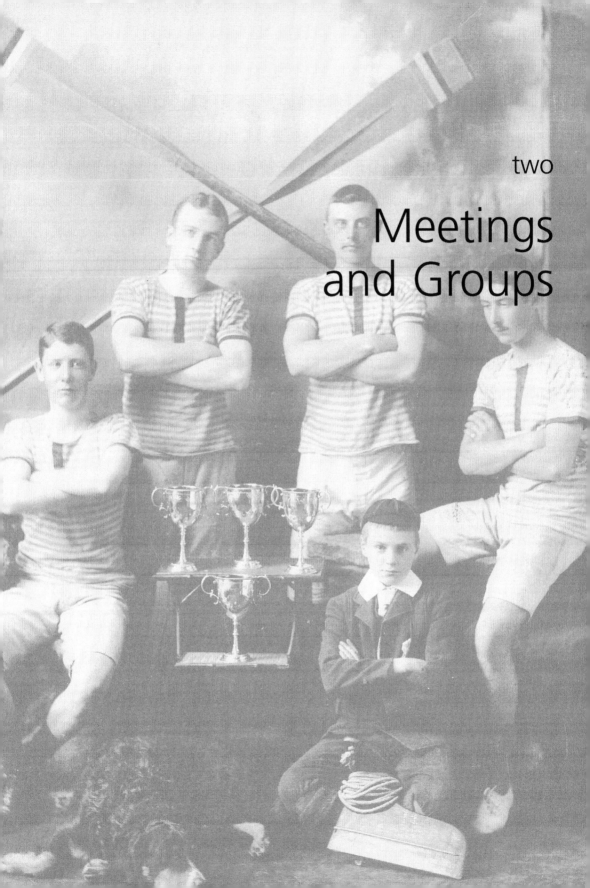

two

Meetings
and Groups

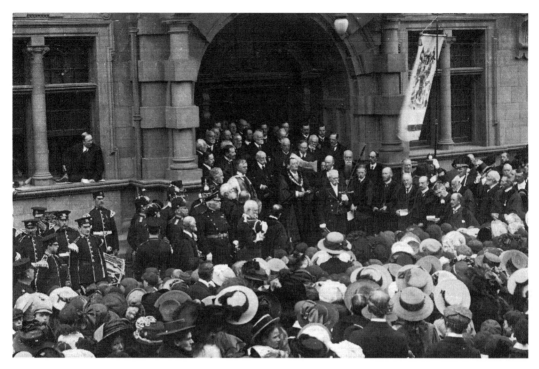

Above: The proclamation of King George V took place on Tuesday 10 May 1910 at the Town Hall before a large assembly. The mayor, Mr Pilley, read the proclamation, the union flag was raised from half to full mast, and the National Anthem played.

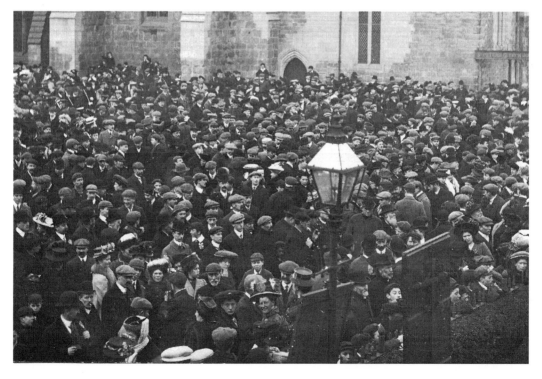

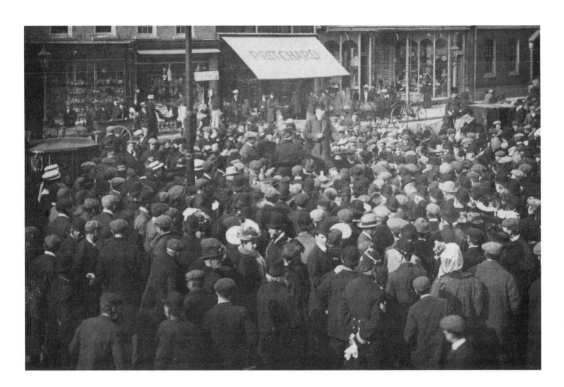

Above: High Town was originally an open market place where many meetings took place. This picture shows Mr De F. Pennefeather speaking below Pritchard's shop sign at a hop growers' meeting on 9 May 1908. The double-fronted shop to the right of Pritchard's is King & Sons who were drapers. The house on the right edge is the Judge's Lodgings, kept by James Ashcroft. Creswell, a butcher whose shop is to the left of Pritchard's and Lismore, a china seller, is next door.

Right: The crowd awaits Sir James Rankin, the winning Parliamentary candidate, to appear on the Mitre Hotel balcony in Broad Street to make his 'thank you' speech on 5 February 1910. Note the extensive police presence below the balcony.

Opposite below: In St Peter's Square, the crowds await the announcement of the election result for the South Herefordshire division on Saturday 5 February 1910. Most faces seem to have an anxious look. The lamppost and two notice boards are at the front of the Shire Hall.

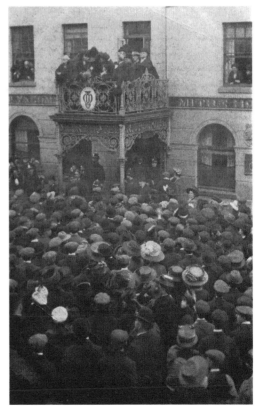

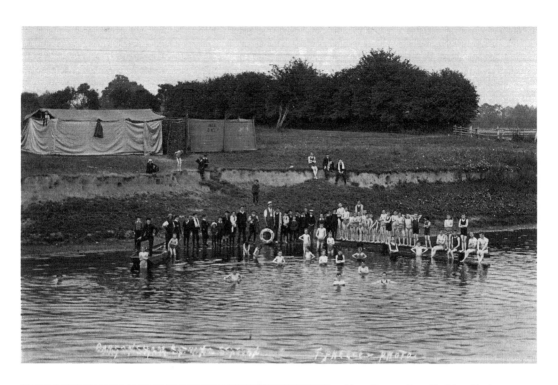

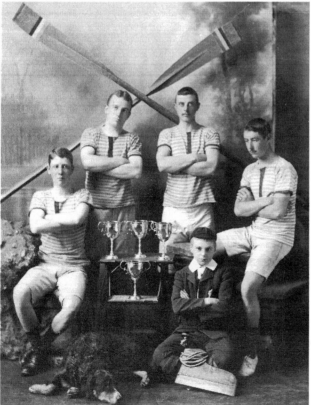

Above: Bartonsham Bathing Station is a temporary looking structure of a tent and sheets of sacking on poles, *c.* 1905. The whole of the swimming club (males only) have assembled for their photograph. A new permanent building opened on 9 July 1910. (see page 96).

Left: At Worcester regatta in 1897, the Hereford Rowing Club coxed four won the Tradesman's Plate. They are, from left to right: L.C. Hatton (Stroke), E.K. Thring (2), H.T. Owens (3), T.P.B. Giles (Cox) and H.C. Hatton (Bow). The two Hatton brothers are the eldest sons of Henry Hatton, who owned the Barton Tannery (see page 2).

Opposite below: The caption on this blurred postcard reads, 'Coronation Day Procession to the Cathedral 22nd June 1911'. The Boy Scouts are part of a parade marching along High Street. The Old House is in the distance.

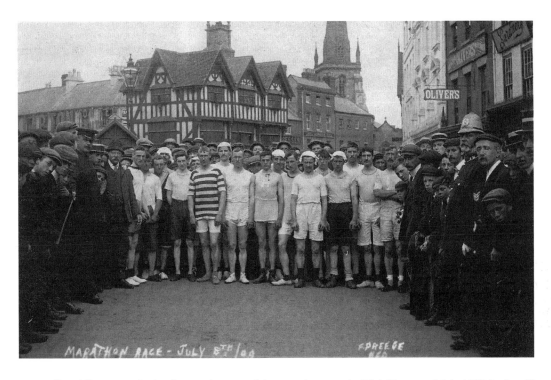

Above: The entrants' grim faces at the start of the marathon race in High Town on 8 July 1909, look as if most of them do not expect to finish. Note the assorted headgear of tied handkerchiefs and large floppy caps, and two are wearing leather shoes.

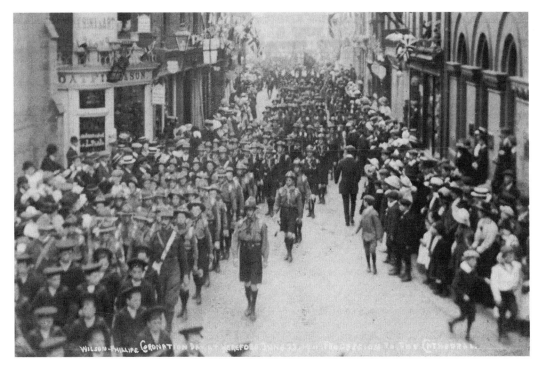

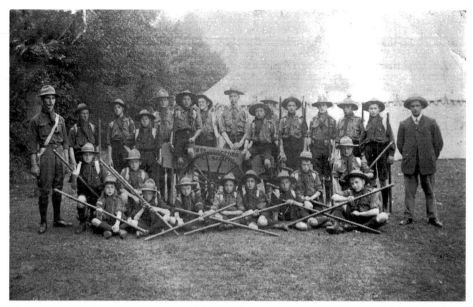

Major General Baden Powell, founder of the Boy Scout movement, visited Hereford in November 1907. He introduced his 'Boy Scouts' scheme to the city at a meeting in the Drill Hall to an audience of about sixty men. Hereford rapidly adopted this idea and by the following year there was an active group. This is the Third Hereford Scouts. Sadly, none of the names are known. Note their troop name on the handcart.

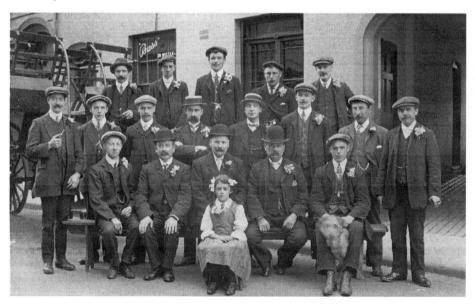

These 'regulars' pose in front of The Royal George, Widemarsh Street, in about 1902, for this photograph taken before a trip in the horse-drawn charabanc. On the back row, fourth from the left, is William Tyler, while his brother is in the middle row second from the right. The landlord Ernest Fleming sits in the centre of the front row with his daughter. Behind the pub were three cottages that were approached through the archway. The Garrick Theatre was on the left. See page 33. (From Margaret Jones, whose grandfather is William Tyler)

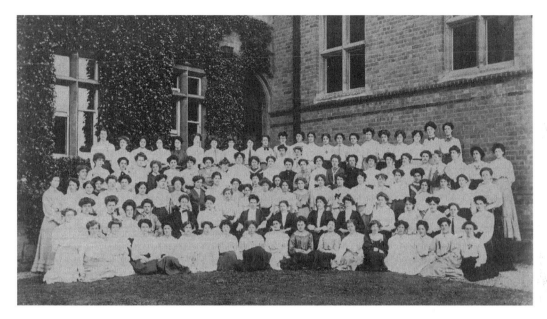

The County College in College Road was built in 1880 at a cost of £17,000. It opened as a boys' school with 6½ acres of grounds. It closed in 1903 when the Herefordshire Education Committee purchased the college and opened it as a training college for elementary school mistresses. The first principal, Miss Sophie Smith, is in the photograph among her staff and pupils.

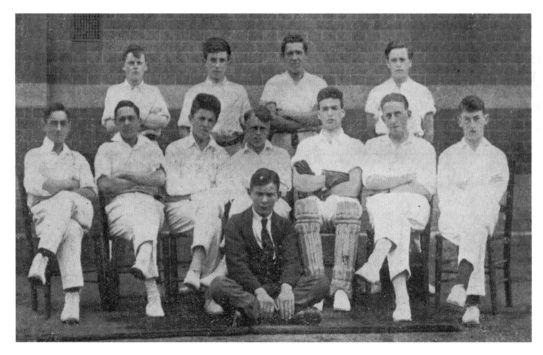

Hereford High School in Widemarsh Street was opened on 14 September 1912 as the Boys' Secondary School, by Sir James Rankin Bart, chairman of the County Education Committee. Here is the 1933 1st cricket team.

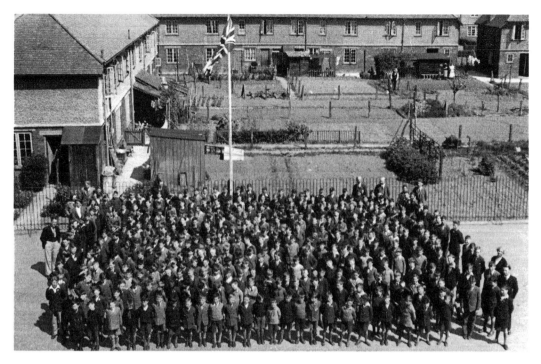

The message on the reverse of this postcard says, 'Norman took this picture on Empire Day 1935 from the roof of St Owens's School'. There are about 300 pupils in this picture.

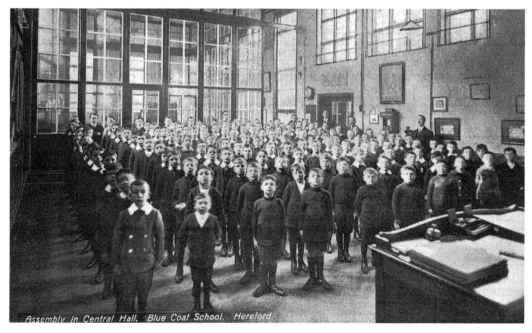

Assembly in Central Hall. Blue Coat School. Hereford.

There are six masters and about 140 children in this Bluecoat School morning assembly. The original school, established in 1710, was replaced with this building in 1827. In 1908 the headmaster was William Coldwell and there were 368 children at the school.

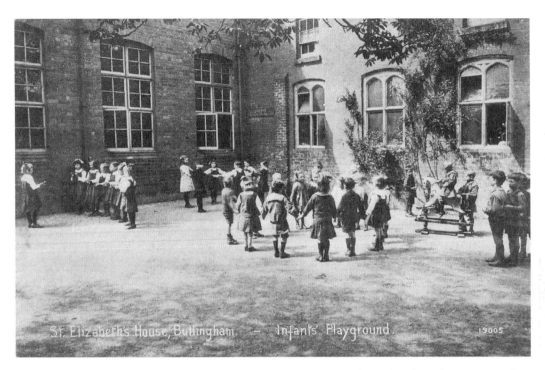

St Elizabeth's School, Bullingham, during a very orderly playtime! The rocking horse has a queue and others wait to join in the 'ring of roses'.

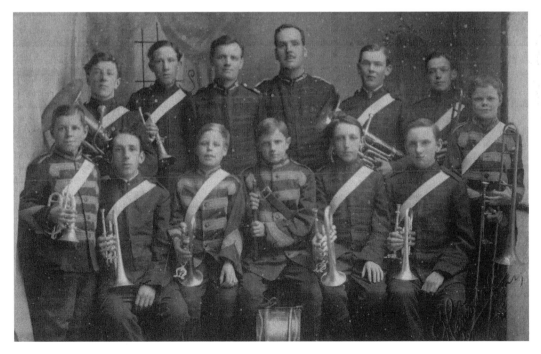

The Boys' Band, wearing smart uniforms, are with their conductors, c. 1917. In the corner of the picture the photographer has embossed his name, 'Hemmings' Edgar Street, Hereford.

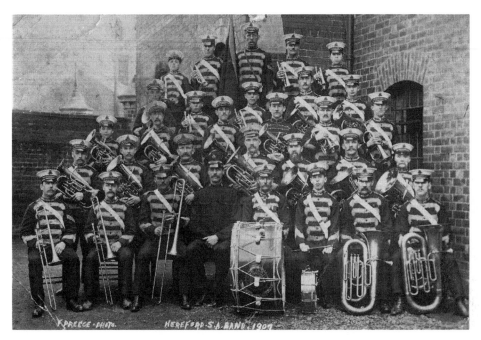

General William Booth, who founded the Salvation Army in 1882, visited Hereford in 1911. The early members suffered riot, bloodshed and imprisonment. This is the Hereford band around 1907 near their barracks, an old wooden warehouse in Widemarsh Street. All the members proudly display their drum and brass instruments.

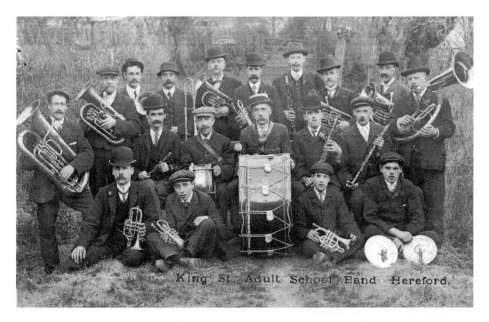

Information on the King Street adult school band has been lost. However, this photograph of the musicians and their instruments appeared in the *Hereford Times* on 20 November 1908 but is without a caption. Note the variety of headwear from the floppy flat hat to the smart bowler. Over 75 per cent of the musicians have a moustache or beard.

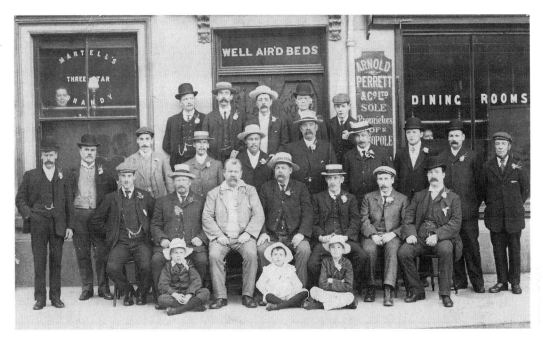

Photographer Savory took this picture of a group of Hereford characters in 1906, who were celebrating some special occasion in front of the City & County Dining-rooms, High Town, near to The Old House. Note that they all have flowers in their buttonholes.

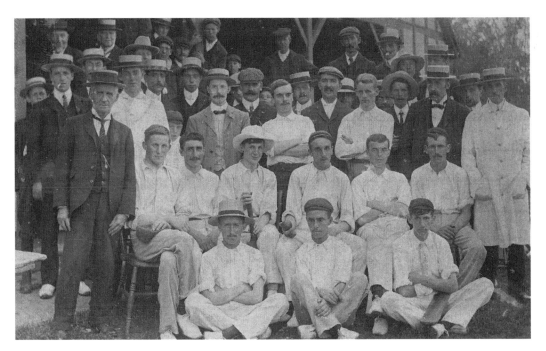

The message on the reverse of this postcard states, 'The Post Office Cricket Team 1904'. The team of eleven have an aggressive look and all are wearing sport shirts. Most of their supporters wear a straw boater. The location of the cricket ground is unknown.

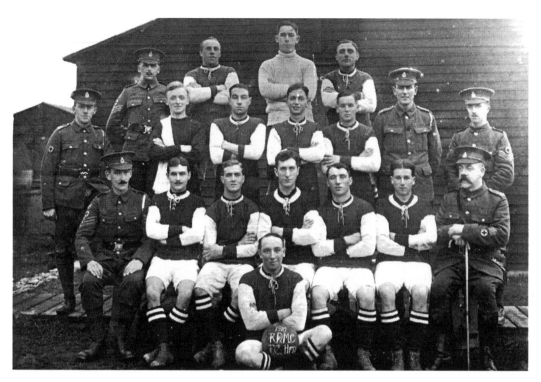

The only information on this 1916 RAMC football team photograph is that it is their Hereford team.

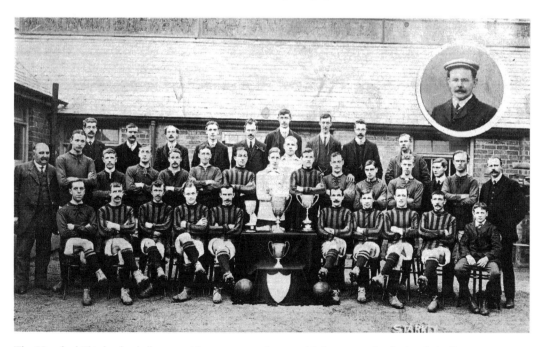

The Hereford Thistles football team with managers, trainers and helpers proudly display their silver trophies. Robert Godfrey Broad is fourth from the right in the top row (see page 84 *lower*). (Judith Morgan collection)

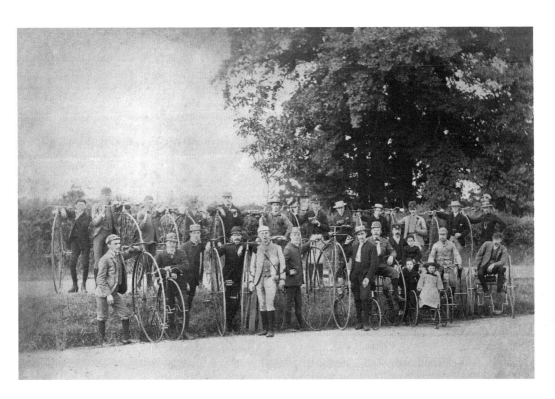

Above: This is the Hereford Cycling Club in 1880 photographed before a club ride. The captain with his miniature bugle is near the centre of the back row. There are eighteen ordinary bicycles of various sizes and some tricycles. Note the two children. (Mike Pugh collection)

Right: A Hereford Cycling Club letter dated 6 March 1891.

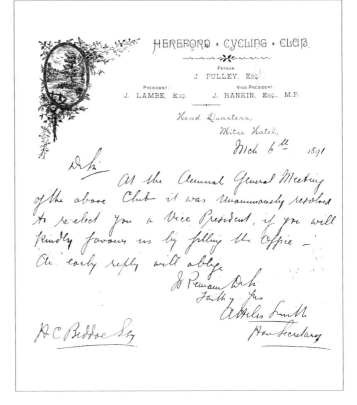

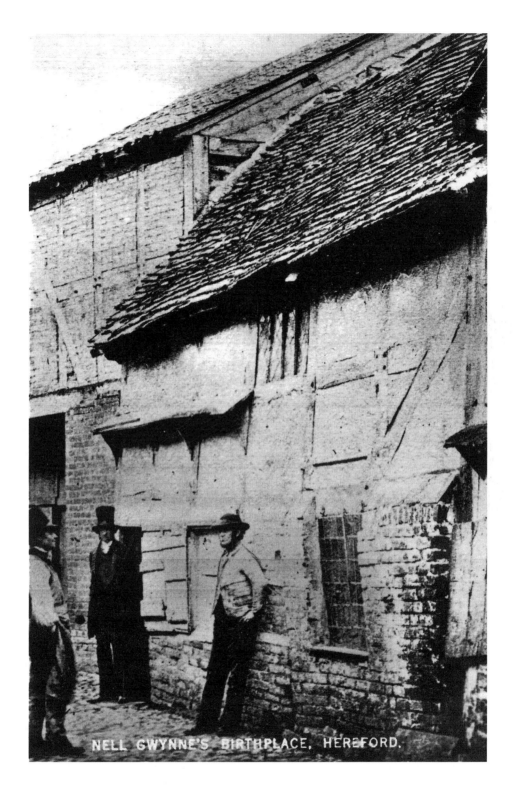

NELL GWYNNE'S BIRTHPLACE, HEREFORD.

A near derelict cottage in Gwynne Street was the reputed birthplace of Nell Gwynne. On the other side of the wall is the Bishop's Palace that was occupied by her grandson Bishop Beauclerk.

three

Local Churches and the Three Choirs Festival

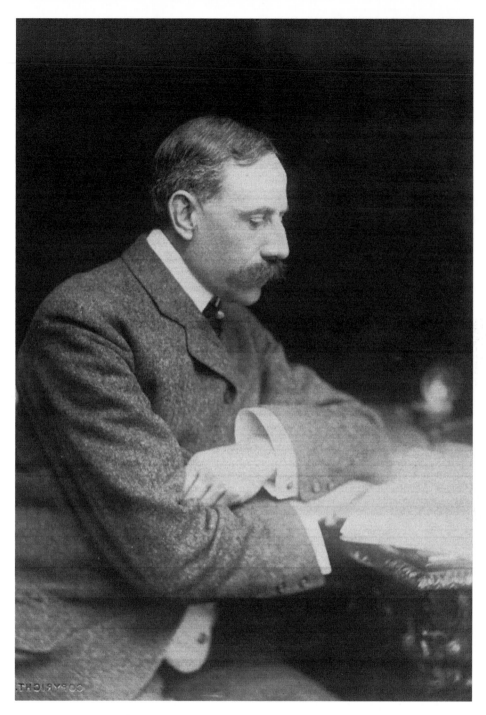

Composer Sir Edward Elgar lived in Hereford from 1904–11 where he composed some of his most famous music including *Pomp and Circumstance March no. 3 & 4* and *Coronation March*. Before he moved to the city he was a frequent visitor and played in the orchestra at the Hereford Festival. From 1883, before he moved to the city, he regularly visited the Hereford Cathedral organist with whom he became close friends. His home was 'Plas Gwyn', Hampton Park Road, about a mile east of the city centre from 1904-1911.

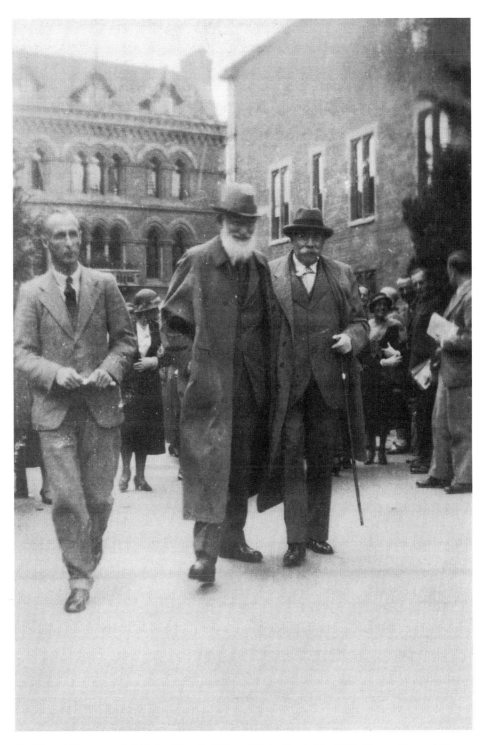

Sir Edward Elgar attended his last Hereford Three Choirs Festival in 1933. George Bernard Shaw accompanied him across the Cathedral Close. In the background is the Hereford Library and Museum.

Above: The 1933 Three Choirs Festival took place in Hereford. The three cathedral organists are, from left to right: Percy Hull (Hereford), Herbert Sumsion (Gloucester) and Sir Ivor Atkins (Worcester). This was the last festival Sir Edward Elgar attended. In 1934 he became critically ill and died on 23 February.

Left: The Three Choirs Festival is held annually in the cathedrals of Hereford, Worcester and Gloucester in rotation. It is the oldest musical festival of its kind in the world (started around 1709). In 1899 the three cathedral organists were, from left to right: Sir Herbert Brewer (Gloucester), Dr George Robinson Sinclair (Hereford) and Sir Ivor Atkins (Worcester).

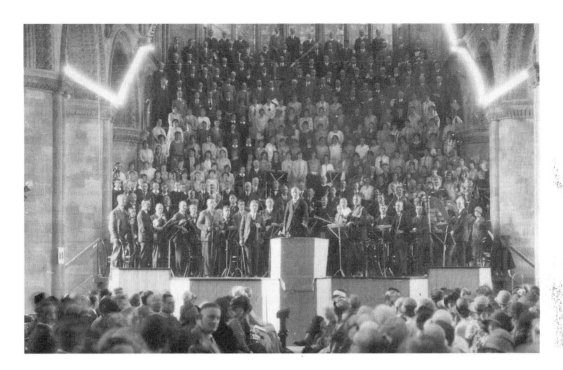

Above: The orchestra and chorus pose for a photograph after a performance during the Three Choirs Festival in the Cathedral, *c.* 1927. The conductor is Percy Clark Hull, Cathedral organist (1918–1949).

Right: Dr George Robertson Sinclair was the Hereford Cathedral organist from 1889–1917. He is shown with his bulldog Dan (1898–1908) in his garden at No.20 Church Street. Dan is seated on stonework, possibly removed from the west front of the Cathedral during its rebuild in 1901–1908. Sir Edward Elgar, who lived in Hereford for eight years, was a close friend of Sinclair's. Both Sinclair and his dog feature in 'Variation XI' of Elgar's *Enigma Variations.*

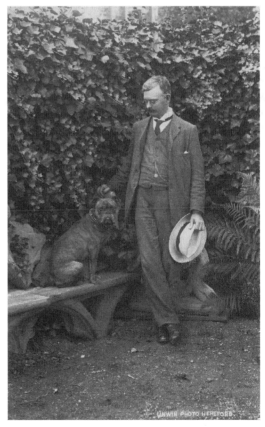

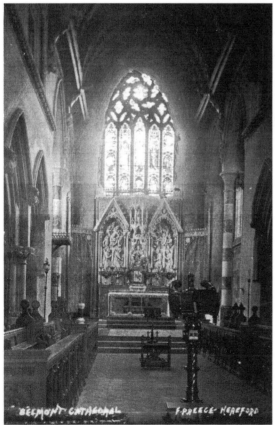

Above: A small group of the 1909 Hereford Three Choirs Festival male voices and musicians pose for their photograph.

Left: E.W. Pugin designed the church at Belmont, which was built between 1854–59 and was financed by Francis Wegg-Prosser at a cost of £45,000. It is of the Decorated style, constructed with local red sandstone and internally faced in Bath stone. The nave is shorter than the original plans intended. The earliest window has Belmont's patron St Michael defeating the dragon in the centre with Archangel Raphael to his right and Archangel Gabriel to the left. The window was repositioned three times during the church's construction. The reredos is of an angelic orchestra with many delicate features. There is a twist in the large timber support on the south side of the roof caused by the earthquake on 17 December 1896. The quake happened during Matins and sent the monks dashing out.

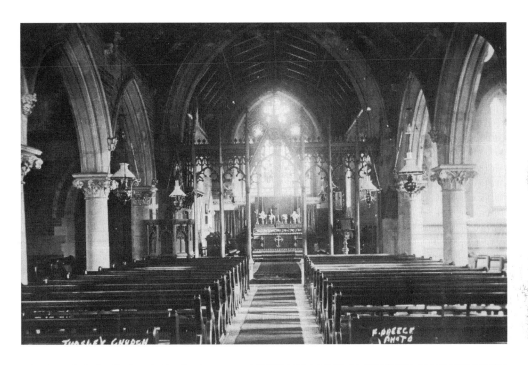

Above: Inside St Paul's church, Tupsley, is an oak chancel screen made in 1909 in memory of John and Elizabeth Mackay.

Right: St Paul's church, Tupsley, seen around 1909, was built of stone in 1864–65 in the Early English style to the designs of the local architect F.R. Kempson. It cost about £2,300 and was consecrated on 17 November 1865. The spire is 100ft high and the nave is 91ft 3in long.

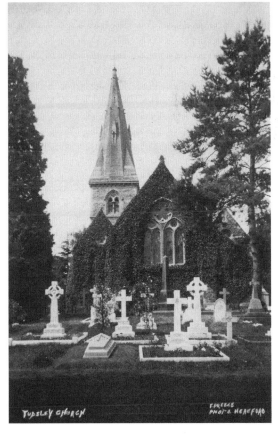

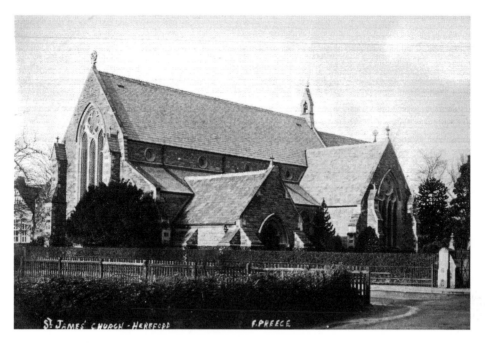

After the 1901 fire St James' church was rebuilt. The walls were constructed from Three Elms quarry stone with the details in Bath Stone. In 1915, the church could seat 550 people. The church register dates from 1869, the year it was consecrated.

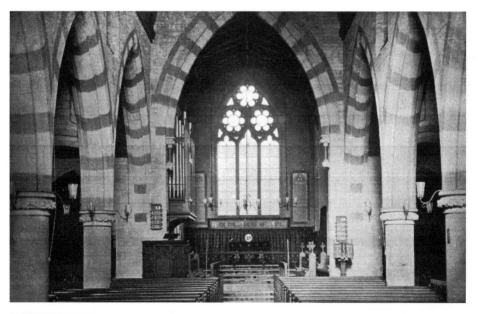

Thomas Nicholson built St James' church in 1868–69 at a cost of £3,900 on land adjacent to the Old General Hospital donated by the ecclesiastical commissioners. The original plan incorporated a tower and steeple that would have risen above the south porch, but these were not built. On 23 December 1901, a fire destroyed most of the church except for the porch and vestry. Restoration in 1902 cost £4,500. Note the gas lamps.

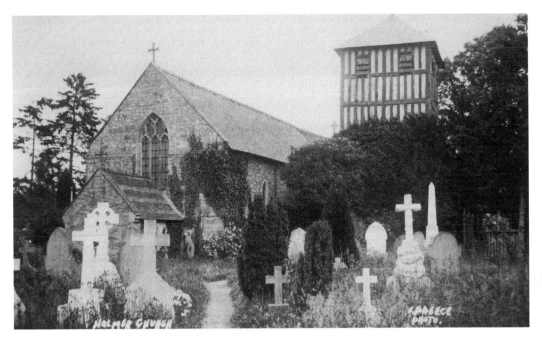

Holmer church, built in the Gothic style, has a detached tower on the south side, which contains five bells. There are six other detached church towers in the county. (Bosbury, Garway, Ledbury, Pembridge, Richard's Castle, and Yarpole)

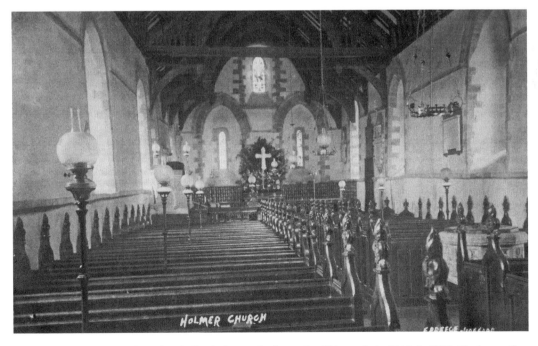

Holmer church, dedicated to St Bartholomew, had seats for 254 people in 1915. In 1865, Hardman of Birmingham created the three lancet windows on the far wall of the chancel in memory of Charles Bulmer who was an extensive landowner in the parish.

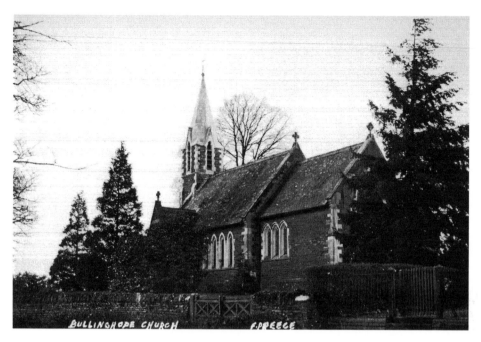

St Peter's church, Bullinghope, is south of Hereford, its parish adjacent to the city boundary. The church, built in 1880, is about 200 yards from the old church ruins. Designed by local architect F.R. Kempson in the Early English style, it cost £2,000.

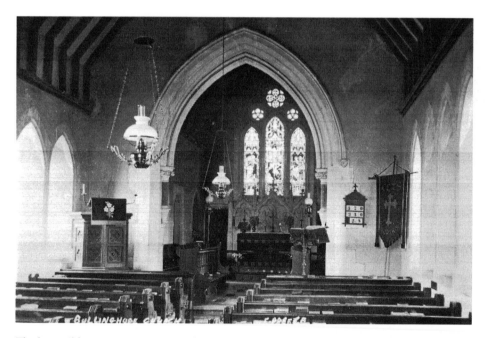

The large oil lamps are prominent inside St Peter's church, Bullinghope. There is a south porch and a double western turret with one bell. A carved reredos is a memorial to the Revd E.H. Daniel MA, who died in 1885. The stained-glass east window is dedicated to Mrs Francis Caroline de Winton of Graftonbury who died in 1885.

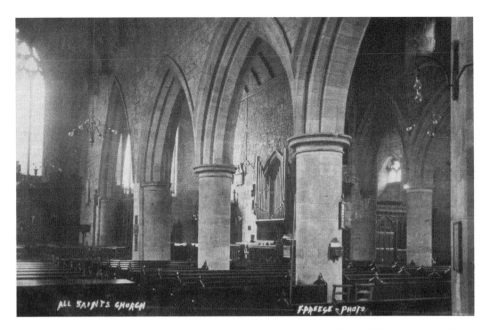

All Saints church at the north end of Broad Street was built in the Early English, Decorated and Perpendicular styles with a chancel, nave, north chapel, south chapel and massive tower with a spire of 225ft. The north chapel has a fifteenth-century hammer-beam roof. During the 1893 restoration at the east end of the church two blocked-up doorways were found, one on each side of the former altar. In the chancel near the organ are ten carved oak stalls and sixteen carved misericord seats.

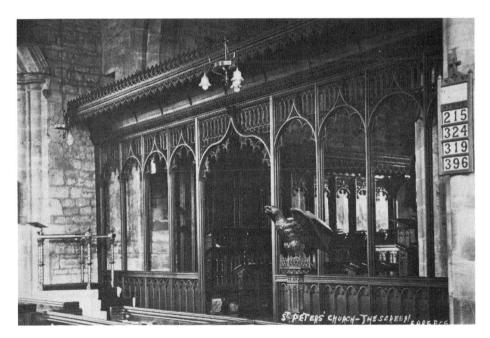

St Peter's church is the oldest parish church in Hereford, founded in 1070 by Walter de Lacy. The church is of the Norman style with an Early English chancel. The carved oak chancel screen was made in 1909 in memory of Joseph Carless, mayor (1861–62) and town clerk (1868–1909).

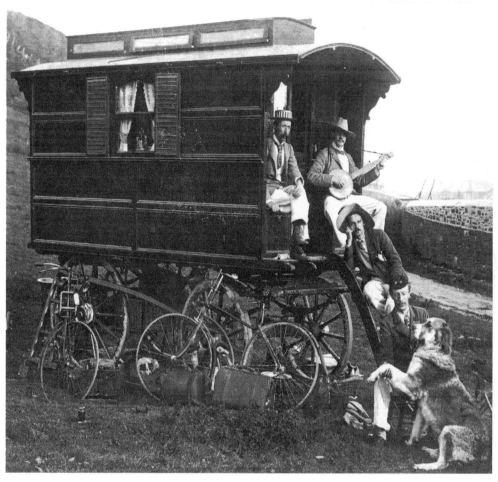

The Hatton family used this superb horse-drawn caravan for an outing to Aberystwyth some time early in 1890. Note the solid bicycle tyres. Mr Hatton, who is halfway up the steps, does not look too pleased with the entertainment.

four

Business and Transport

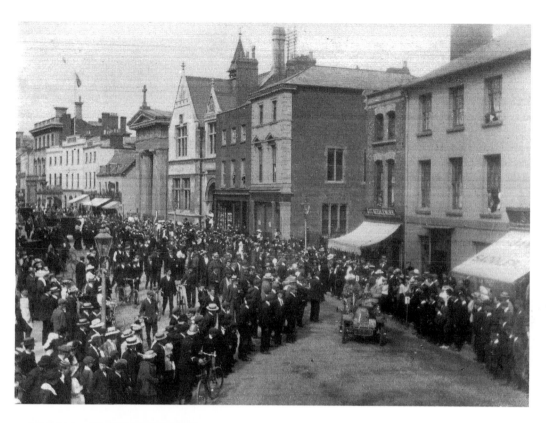

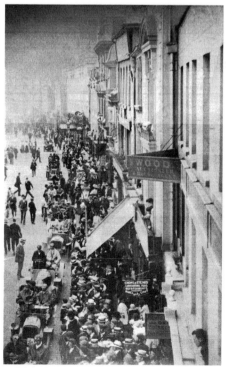

Above: Ever since the original 1896 London to Brighton car run, motorists have set out on reliability trials of all sorts. One of the most important was the Royal Automobile Club, Hereford Small Car Trials during the week 29 August to 3 September 1904. This trial, for cars that cost less than £200, tested reliability and thus promoted the idea that small cars were a trouble-free form of transport. Each day, from Monday to Saturday, the cars had to complete a non-stop 100-mile run on a different route. This is a view of the start in Broad Street.

Left: The Hereford Light Car Trials took place in Herefordshire during September 1904. The car in the foreground, No.24, which was made by Mobile Motor & Engineering Co. Ltd, ascended Fromes Hill with four people on board at 8.6mph. At the end of the trials, the observer on board reported the following incidents that prevented a non-stop run: a nail in the tyre, a seized pump and a broken inlet valve. One local spectator was the Reverend H.J. Morgan of Stoke Lacy who drove the Lanchester car registered CJ 22 visible in the far distance. His son, H.F.S. Morgan, founded the world-famous Morgan Car Co. in Malvern.

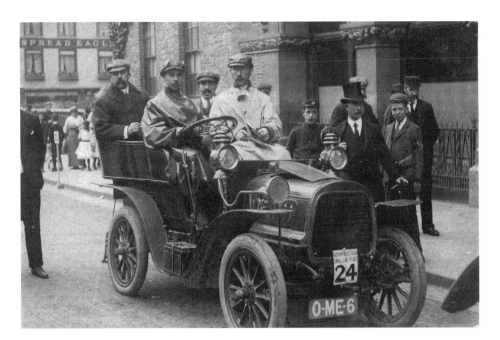

This 8hp Mobile car entered by the Mobile Motor & Engineering Co. is waiting for the start of the 1904 Light Car Trial in Broad Street outside the Museum. The driver is John Bright-Street from Birmingham who finished fifth in his class with seven non-stop runs over the six days (there were two runs each day). Mr Gurney, owner of a grocery shop in High Town, is in the rear left-hand seat.

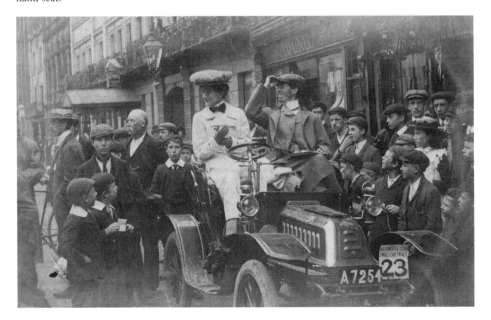

The Hon. Dorothy Levitt was the only woman driver who entered the Light Car Trial. She drove a 6hp French-manufactured De Dion car entered by the national importer De Dion Bouton Ltd. She finished with an excellent result of eleven non-stop runs out of twelve. Sadly, there are no photographs of her taken at the finish showing how her white coat survived.

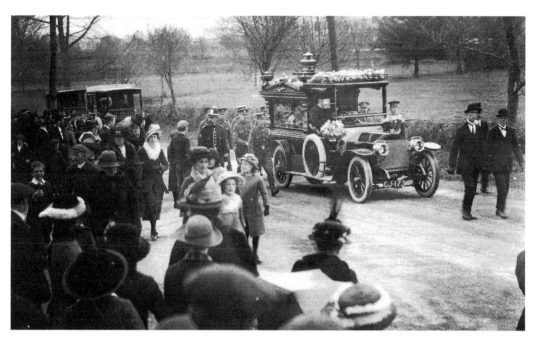

This funeral procession took place in Westfaling Street, *c.* 1908 The hearse is a Wolseley landaulet, owned by Connelly's of Commercial Road.

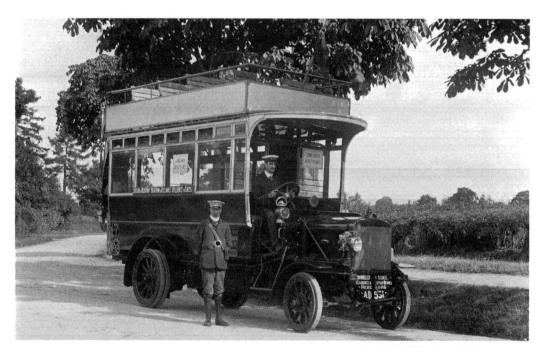

In 1908 there was a regular motor bus service between the railway station and the Whitecross Monument. Here is Connelly's omnibus with the driver and conductor at Whitecross around 1908. The sign on the front reads, 'Connelly & Sons, Carriage and Motor Works Hereford', a company who built carriages in their Commercial Road works.

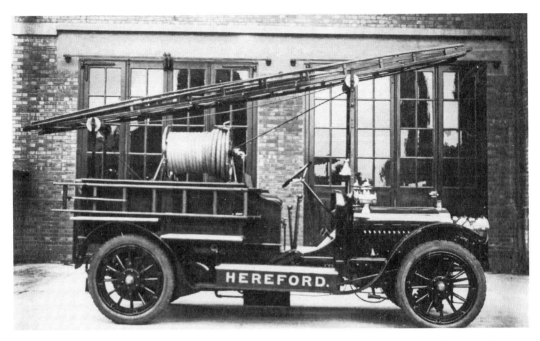

Firefighting in Herefordshire was the responsibility of the local police force, and the chief constable was also the chief fire officer. This fire engine, a Merryweather, is outside the fire station in Gaol Street.

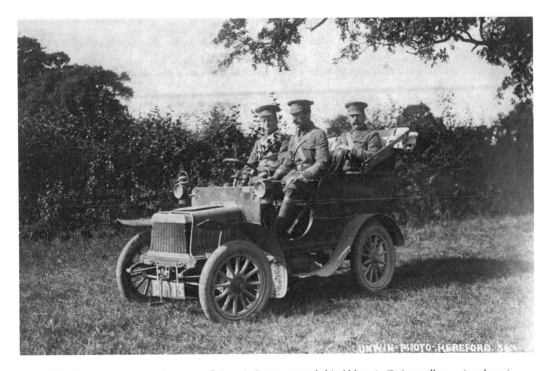

T.A. King, a monumental mason of Victoria Street, owned this Aldays & Onion yellow painted car in 1904, registered CJ 183. Mr Simpson is driving with Major Phillips in the back seat. They are on their way to a TA meeting.

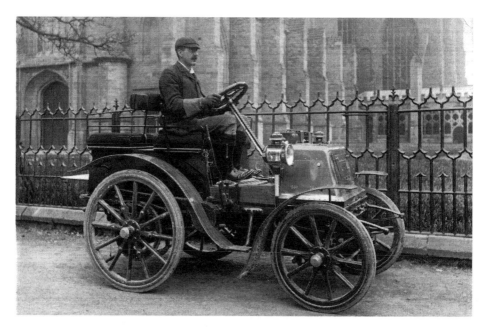

The very early years of motoring were for the rich and adventurous as cars were expensive and unreliable, though mechanically simple. This car, an 1899 MMC (a Daimler made under licence) is parked in front of the Cathedral around 1900 with James Tudor Hereford of Sutton Court, Mordiford, in the driving seat. He was born in 1869 and was one of the first Herefordians to own a car.

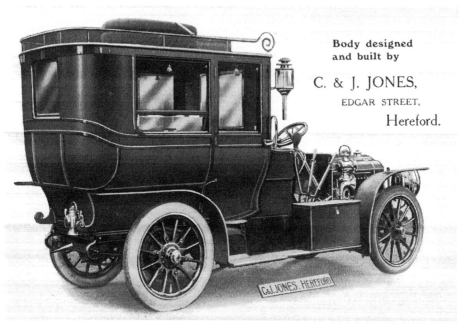

Body designed
and built by

C. & J. JONES,

EDGAR STREET,

Hereford.

Hereford was not known as a car-manufacturing town. However, one local firm, C. & J. Jones of West End Carriage Works, coachbuilders in Edgar Street, made some first-class handmade motorcar bodies. This is their advert on an undated postcard from around 1910.

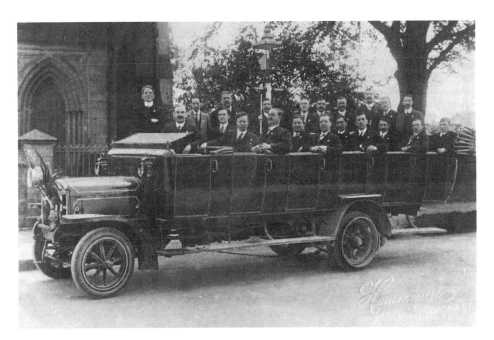

This charabanc with twenty-one male passengers is ready to leave from outside St Martin's church, Ross Road. The bus has minimal weather protection, a single large acetylene headlamp, oil sidelights, six doors on each side and solid rubber tyres.

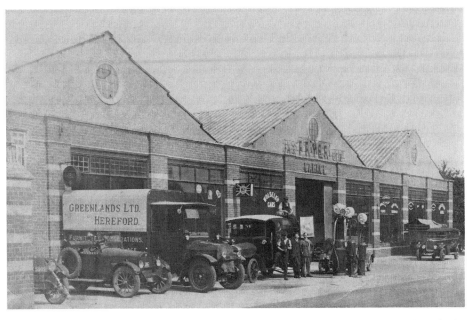

In 1926 Fryer's Garage in Widemarsh Street sold a variety of brands of petrol from hand-cranked pumps. The car on the left is a Studebaker; on the right is a Hillman 14 with a local registration number CJ 9887. Proprietor Mr G.H. Butcher, a keen cyclist and a well-known motoring writer, used the pen name 'Dragon'.

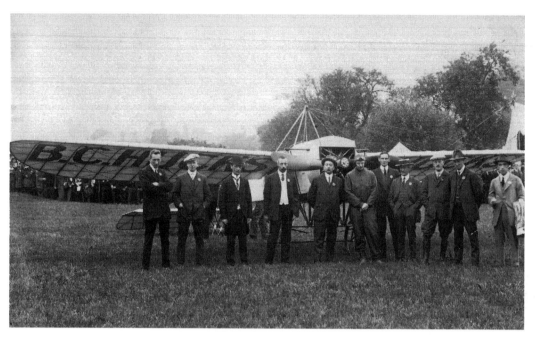

On 3 September 1913 this aeroplane landed on the Bartonsham meadows to refuel. There is a huge crowd behind the plane. The pilot in overalls is in the middle of a group of local dignitaries.

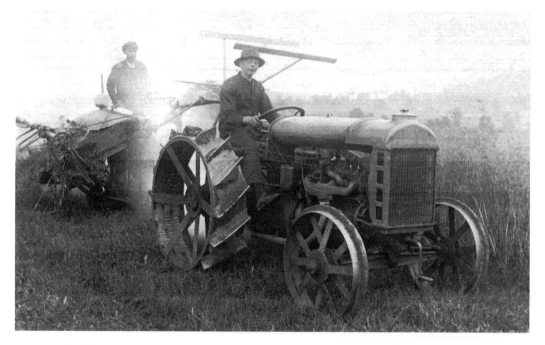

Herefordshire, an agricultural county, employed many people on its farms. For centuries horses ploughed the fields, but with the introduction of the internal combustion engine, tractors took over. This Fordson tractor, thought to be the first in the county, is harvesting in a field near Holmer in around 1914.

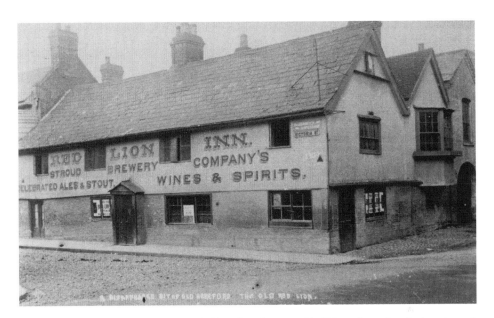

The Red Lion Inn in June 1900 was a half-timbered stuccoed building, situated at the junction of Eign Street and Victoria Street. The Red Lion proprietor's husband, Charles Cox, is in the porch. Charles was a pattern maker and not interested in the pub. At the rear of the inn was a large stable yard, which was always full on market days.

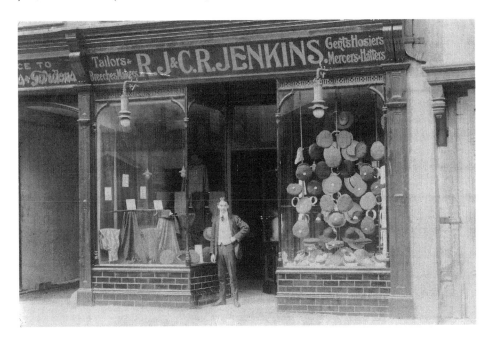

A young Mr Jenkins stands outside his shop at the Mansion House, 11a Widemarsh Street. He advertised as a tailor and breeches maker but his window display concentrates on a hat collection. The exterior gas lamps illuminate the shop window. The shop opened in 1907 just after the ground floor rooms of the Mansion House were converted from domestic use into two shops either side of an archway.

Above: This rare, damaged Victorian photograph of the monumental mason and his assistant was taken in Hereford, but by whom and where?

Left: James Brookes, the proprietor of the White Lion, Maylord Street, stands outside with his wife and six children.

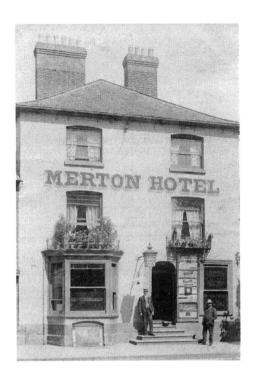

Right and below: The Merton Hotel, Commercial Road, was first mentioned in an 1863 advertisement as a general posting house, supplying funerals and with its own omnibus to take guests to the railway station (Shoesmith – *Pubs of Hereford City*). In 1908 the proprietor was Edward Foster.

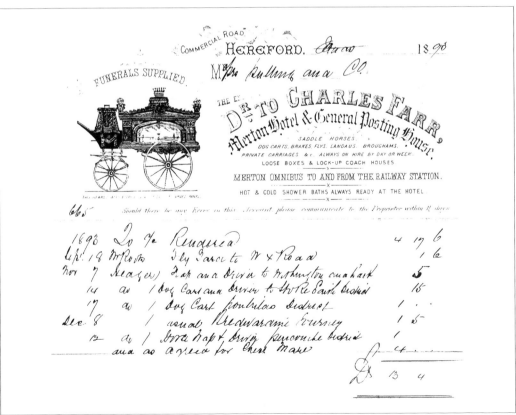

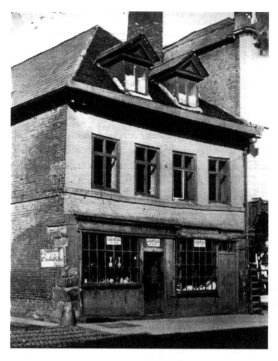

This picture of Miss Mary Wright's china and glass shop, which stood on the corner of Commercial Street and Gomond Street, was taken on 17 September 1910. The notice in her window advertises a 'clearance sale'. The building is in a poor state of repair, due for imminent demolition.

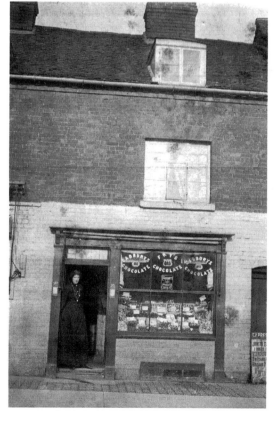

Lucy Mary Broad (née Charles) stands in the entrance to her confectionery shop at No.7 Commercial Road. The shop on the left is Cook's, a taxidermist. Her husband Robert is in the Hereford Thistle football team photograph. (see page 58 *lower*). (Judith Morgan collection)

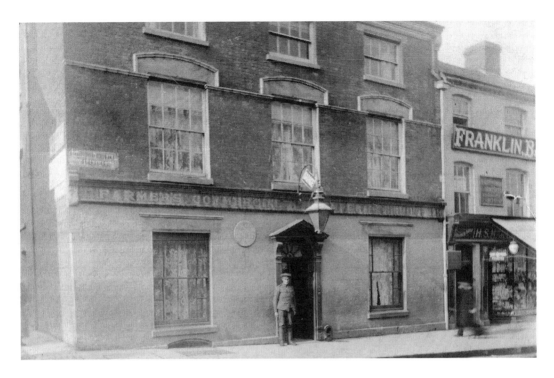

Above: Mr Rodgers was the owner of the Farmer's Hotel, Commercial Road, *c.* 1905. The front is of a Georgian design with interesting stonework above the windows. Note the gas lamp above the door. Next door is Franklin Barne's shop, a seed & grain merchants. The corner on the left leads into Blueschool Street.

Right: An advertisement by Franklin Barnes, Commercial Road, in 1909, proclaimed that they, 'sold grain, seeds of all sorts, forage for horses and stuffs of all kinds'. They manufactured their own animal feeds in a large warehouse behind the shop and were contractors to HM Government and Army. Mr Barnes stands between his employees.

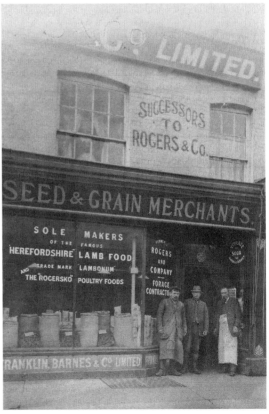

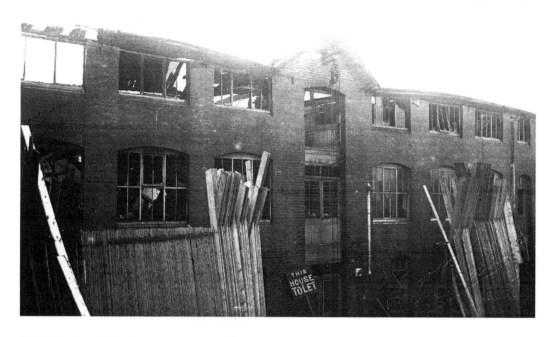

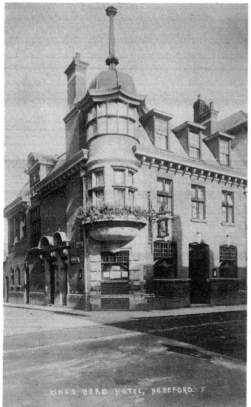

Above: The strategically placed sign, 'This House To Let', is on the fire-damaged building. The building remained unidentified until the author found a 1950s photograph taken from Victoria Street of a city wall bastion that had this building in the background. It was owned by Holloway & Webb who had a marquee business.

Left: In 1907 Alfred Willis was the proprietor of the King's Head at the corner of Broad Street and West Street. It had four entrances and an attractive corner turret.

Opposite below: The Herefordshire General Hospital operating theatre had every modern convenience in this May 1929 photograph, but no staff. The operating table had a hydraulic rise and fall system, while the surgeon could sit down on the stool. The two open doors lead into the anaesthetic and recovery rooms.

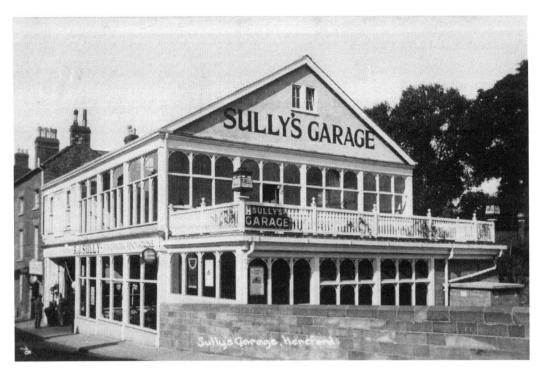

Above: John Watkins, a carriage builder, occupied the house on the north-west corner of the Wye Bridge from 1876. He sold the business to Richard Sully. This is his fine new garage and showroom soon after reopening around 1920.

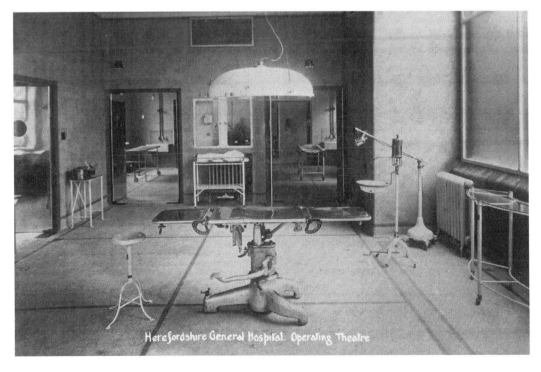

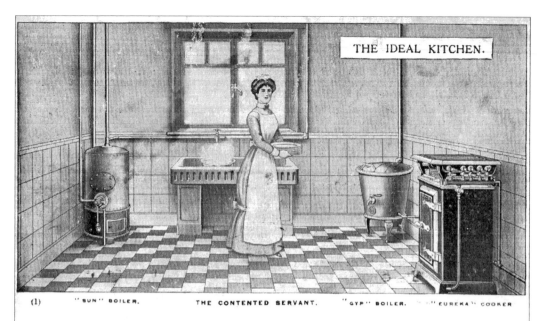

THE IDEAL KITCHEN.

(1) "SUN" BOILER. THE CONTENTED SERVANT. "GYP" BOILER. "EUREKA" COOKER

HEREFORD CORPORATION GAS DEPARTMENT.

Hereford Corporation.

GAS DEPARTMENT.

Telephone Nos.: Gasworks 1124. Showrooms, No. 1283.

GAS COKE. Broken, for Domestic use and for Anthracite Stoves.

Unbroken, for Hop drying, Greenhouse heating, &c., &c.

SMITHY BREEZE. Broken to the size required, and screened.

SULPHATE OF AMMONIA. The best nitrogenous manure. Guaranteed 20 % nitrogen.

TAR. Crude, for Fences, &c. Prepared, for use on roads.

Cooking Stoves, Gas Fires, Boilers, &c.,
SOLD and LET ON HIRE.

A large Stock of Gas Fittings and Apparatus on view at West Street Showrooms. Inspection invited.

High Pressure Gas Lamps for Shop Lighting.

WATER HEATERS for domestic use, including Gas Boilers for connection to existing pipes, and enabling hot water to be obtained without lighting the fire.

FOR ALL PARTICULARS APPLY TO

**THE ENGINEER AND MANAGER,
GAS WORKS, HEREFORD.**

Above: In 1921 the Hereford Corporation Gas Department posted this interesting postcard to Mr Rudd, 'Bird Specialist', Norwich. Hopefully he received it with this short address. In front of the sink and between the two boilers and cooker is the 'contented servant' that made the ideal kitchen.

Left: This advertisement appeared in a 1922 magazine.

Augustus Edwards owned a large shop in High Town near the Old House. This advertising postcard is from around 1914.

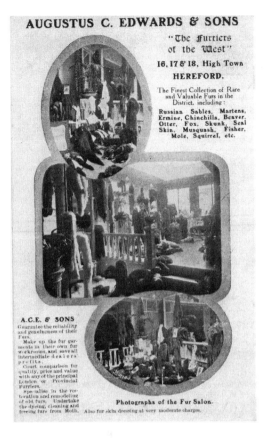

A 1921 advertisement for Augustus Edwards' shop, with a thumbnail sketch.

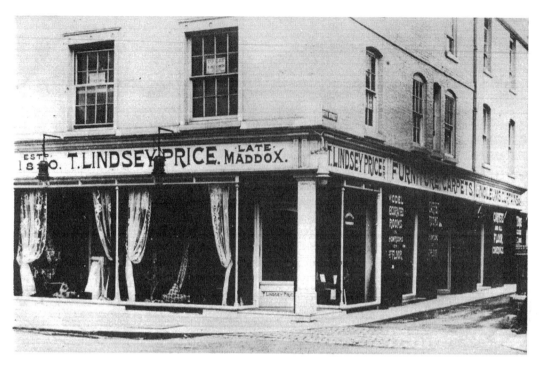

In 1913 Lindsey Price occupied the corner of St Peter's Square and Offa Street. He sold carpets, linoleum, furniture and curtains. Soon after, the shop moved into new premises in Commercial Street.

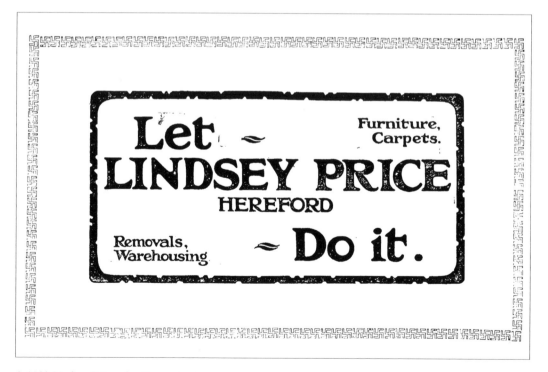

A 1922 Lindsey Price advertisement.

five

River Wye

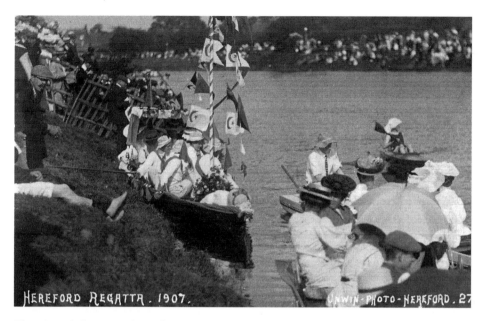

There is no information about this regatta. It is a sunny day and seems to be great fun with everybody dressed for the occasion.

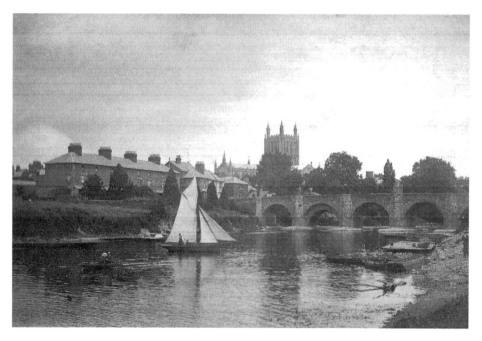

Above: This sailing boat was reputed to be the last such craft built, *c.* 1895. The sailor is looking at the approaching rowing boat with a sharp eye.

Opposite below: The high river level always attracts the photographer. At Jordan's boat yard the children watch the spectacle of the high water. Just out of view to the right is a stone building that was the terminus for the Abergavenny and Hereford horse-drawn tram road.

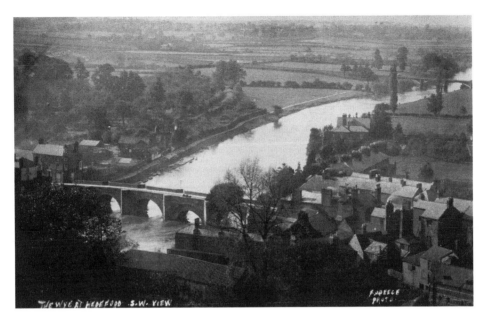

Above: This dull winter photograph of Hunderton and the Wye Bridge was taken from the Cathedral tower. The river is high and the road over the bridge deserted. The bridge, built in 1470, has a solitary gas lamp. The curved double line of trees near the centre of the picture marks the route of the Hereford and Abergavenny Tram Road, opened on 21 April 1829 and closed on 1 May 1853. On the opening day fifteen trams of coal arrived from Blaenavon and eighteen from Pontypool at Mr Cook's wharf, which is just visible adjacent to the floating boat stage above the bridge. In the foreground is the roof of the Bishop's Palace coach house. In the distance is Hunderton railway bridge, the second built for the Hereford and Abergavenny Railway (opened in December 1853). The buildings on the lower right are part of Bridge Street, Gwynne Street and Wye Terrace.

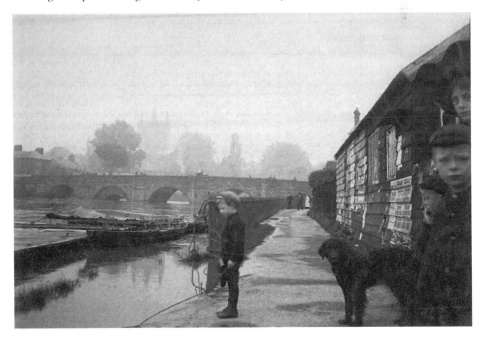

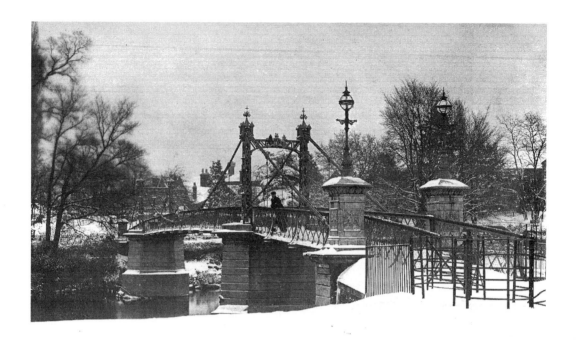

Victoria Bridge is shown covered in 6ins of snow. The river level is low and one pedestrian poses for the photographer.

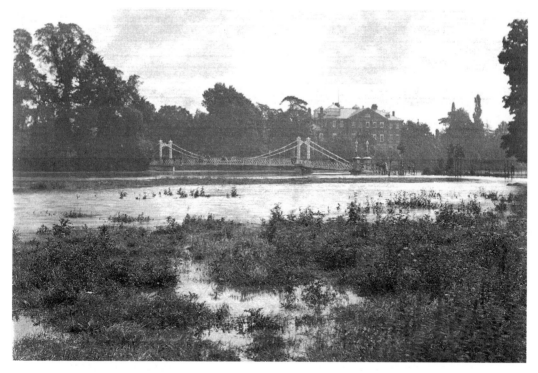

The recently opened Victoria foot bridge and the General Hospital are in the background in this 1899 flood picture. The earliest part of the hospital was built in 1781.

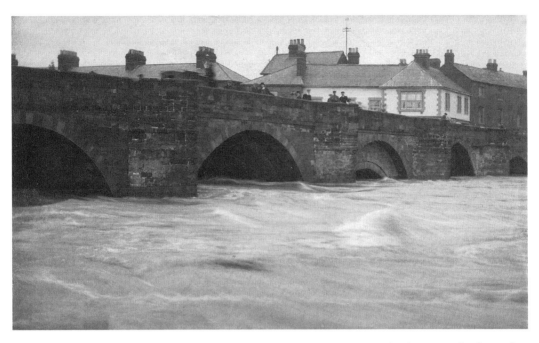

Hatton the photographer stood on the edge of the 1899 flood to capture this shot. Note the shape of lowest bridge arch that was demolished during the Civil War.

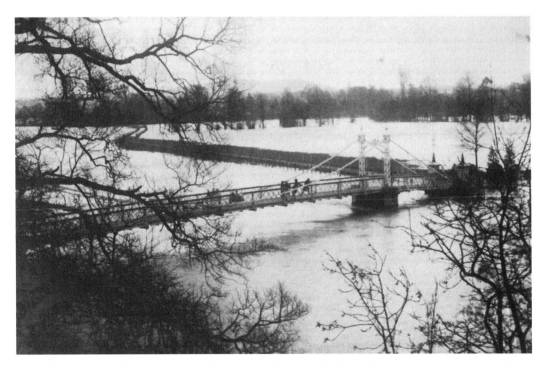

The Victoria Bridge just clears the December 1910 flood of 16ft 6in. The adjacent meadows are under several feet of floodwater. In January 1899 the flood level was 17ft 6ins while in 1852 the flood reached 20ft.

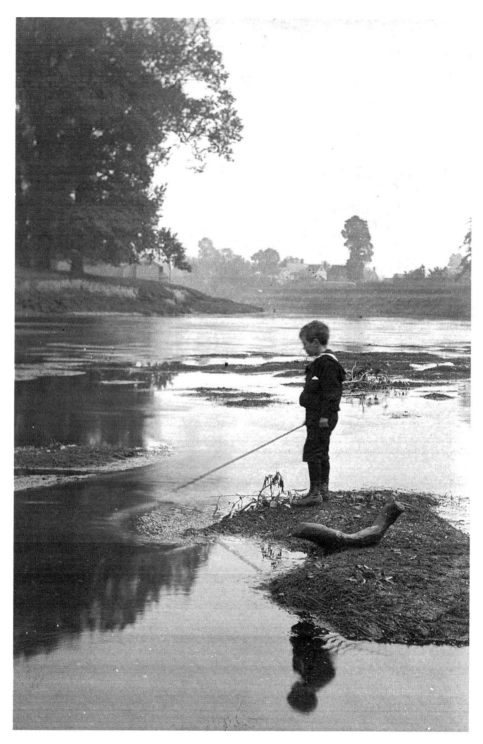

Young Hatton in his sailor's uniform is fishing in the middle of the river, downstream from the Victoria Bridge. The Bartonsham Bathing Station is visible on the left bank (see page 50 *upper*). In the distance is Wyeland House, Putson.

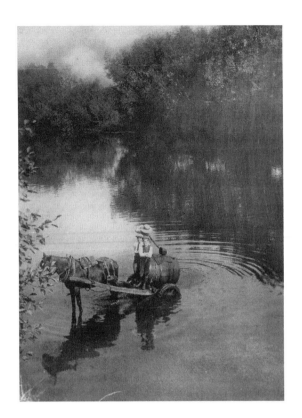

The caption on this postcard stamped 10 August 1914 reads, 'taking water at Putson'.

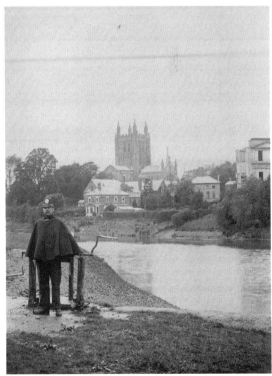

PC Bromage pauses during a wet autumn day next to the ferry winding point opposite the Castle Green, *c.* 1895. The Science and Art School sign is just visible.

Above: The youngest members of the Hatton family enjoy an afternoon on the pebble shore opposite the General Hospital, *c.* 1895. One, with his homemade fishing tackle, is showing an interest in the family's fishing business (see page 2), while another waits for the breeze to blow his toy yacht.

Left: The river is high and rising just before the peak of the 1899 flood. The Hereford cow is on the bank near Putson.

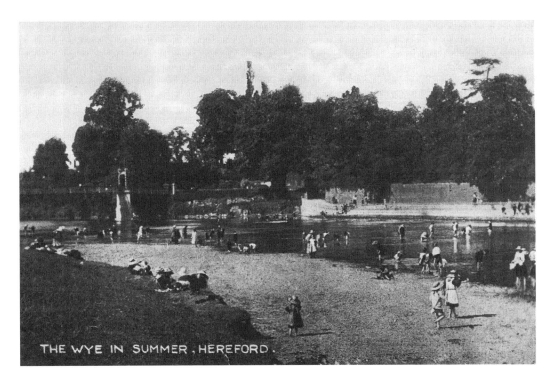

THE WYE IN SUMMER , HEREFORD .

Above: It is high summer with a low river level, *c.* 1930. The children are able to wade almost across the river. The beach is all pebbles and stones, not kind to the bare feet. This area is the site of Hereford's second ford.

Right: Hatton took this rare photograph of a Wye barge near Tintern. This type of boat plied the river Wye as far as Hereford. Trade virtually ceased once the railways arrived.

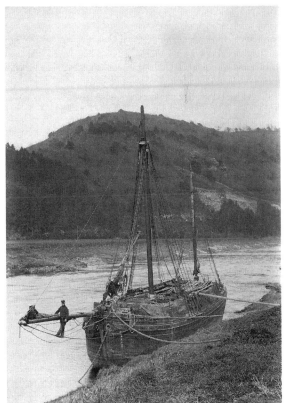

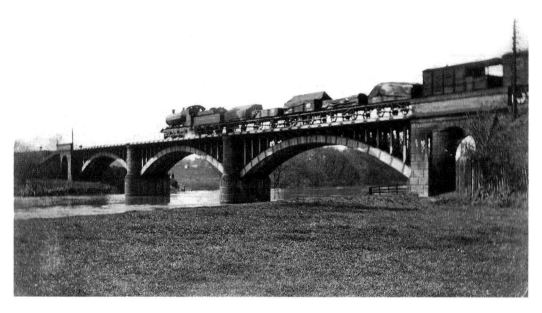

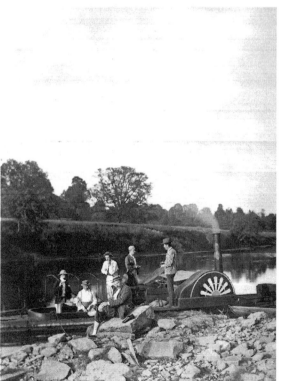

Above: Charles Liddell designed the railway bridge at Hunderton, built in 1853 for the Newport, Abergavenny & Hereford Railway. The bridge is 272ft long and the spans are 85ft wide. This goods train is heading towards Barton Station.

Left: On 2 July 1894, a hot summer's day, the Hatton family take afternoon tea near Belmont. The steam paddleboat known as *Parker's Steamer* was the only one ever recorded to have used the river at Hereford.

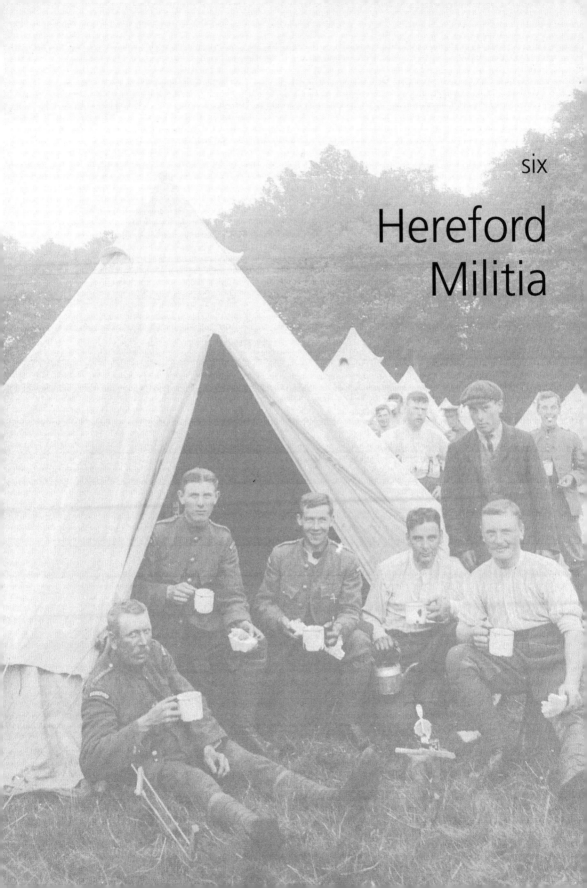

Hereford Militia

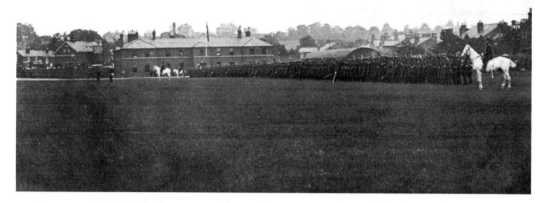

The Militia Barracks in Harold Street are home to the 1st Battalion Herefordshire Regiment which is receiving its new colours on 31 July 1909. The Colonel Commandant is Lt-Col. Edward Scudamore Lucas Scudamore. It was also home to the 1st Herefordshire rifle volunteer corps, made up of three companies and a bearer company. The commanding Lieutenant Colonel was M.J.G. Scobie.

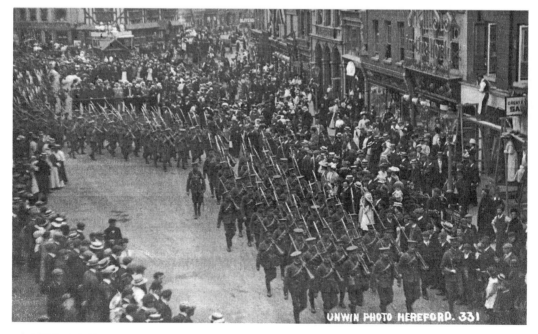

On 27 July 1908 the Herefordshire Battalion of the Territorial Army assemble in High Town for their fortnight's annual training. Note the shopkeeper on the right who put up trestles and a plank to get a better view. He has blocked the entrance into Capuchin Lane and Church Street. Boots the Chemists are next door. There are three distant double-deck omnibuses with their open-top decks crowded with female spectators.

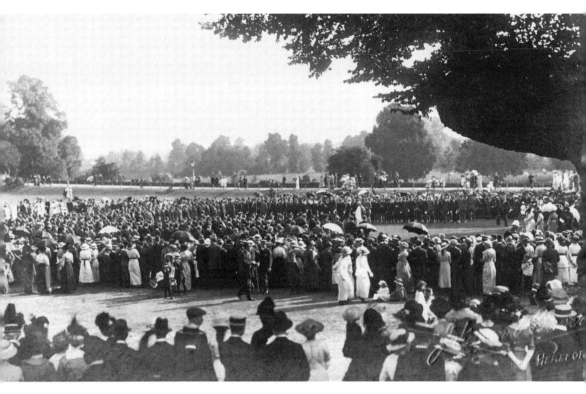

The message on the postcard is 'Drum Head Service on September 6th' but the year is not noted.

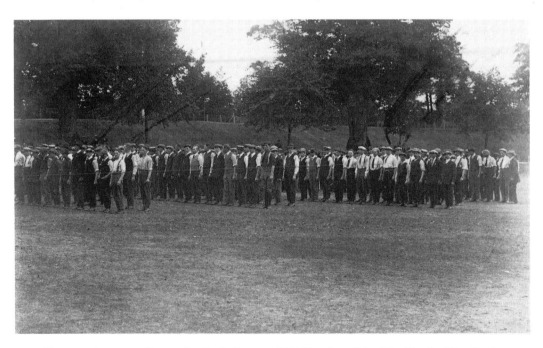

New recruits are parading on the Castle Green, *c.* 1915. They have joined the Herefordshire Regiment and will later fight on the continent. One wonders just how many came home at the end of the war.

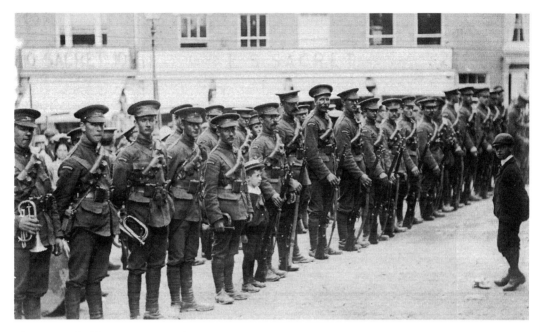

The 1st Herefordshire Regiment with its musicians is on parade and inspected by the boy on the right, *c.* 1910. Note the new recruit (a young Hatton) in his boater and sailor's uniform. We can only speculate just what the sergeant said on his return!

There is a message on the reverse of this postcard, posted in Hereford on 15 October 1914, that reads, 'section 2 of the company'. These are new recruits relaxing before training.

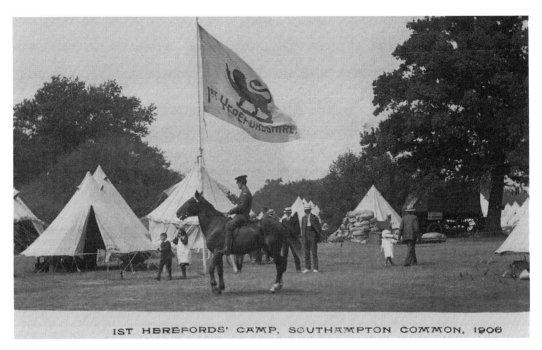

IST HEREFORDS' CAMP, SOUTHAMPTON COMMON, 1906

In 1906 the 1st Herefordshire Regiment, at their annual camp near Southampton, proudly fly their flag. Note the air–conditioned tents.

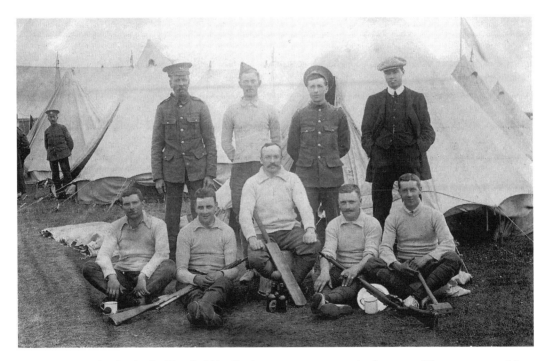

It is a rest day for the 1st Herefordshire Regiment on manoeuvres in the county. There are seven soldiers dressed in civilian clothes who display their guns, sports gear and, most importantly, three unopened beer bottles.

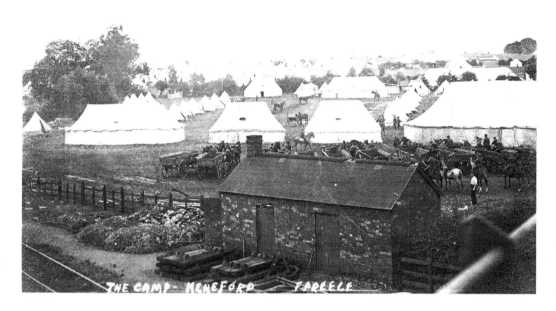

THE CAMP - HEREFORD PREECE

Above: This picture of a large combined military camp on College Hill, Hereford, was taken by Preece, the photographer, in August 1912, from Newtown Road Railway Bridge. The camp covered an area from the college all the way down to the railway bridge. Fifteen horse-drawn military carriages are just visible. The railway building is a store and a tea shed.

Left: Members of the 1st Herefordshire Regiment are seen relaxing during manoeuvres in the county. The occupants of the surrounding tents, all with a mug of tea, are keen to be in the photograph.

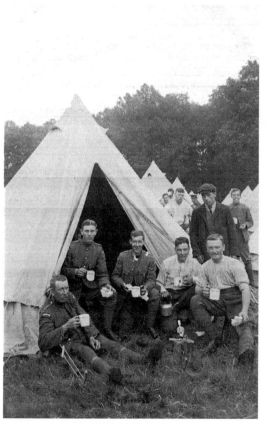

The Castle Green and Empire Days

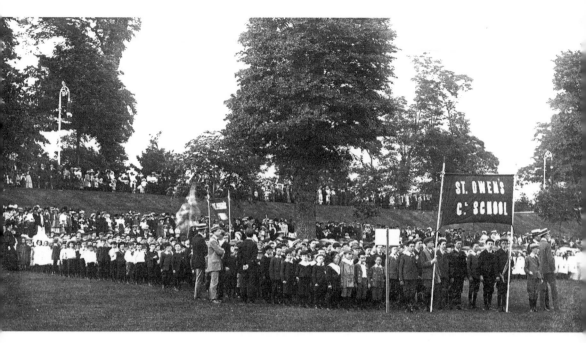

Castle Green was the venue for many public events including Empire Day on 24 May 1908 (Queen Victoria's birthday). At the end of Queen Victoria's reign patriotism was at its height and children from all the city schools attended and marched past the mayor and dignitaries. Watched by their parents and friends, they then marched out of the Castle Green by diagonal routes, creating a kaleidoscopic effect.

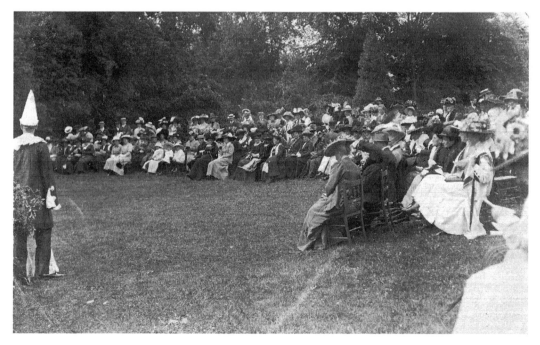

The Herefordshire Hospital's fundraisers held regular events. This postcard, posted on 18 July 1912, shows a clown entertaining a predominately female audience.

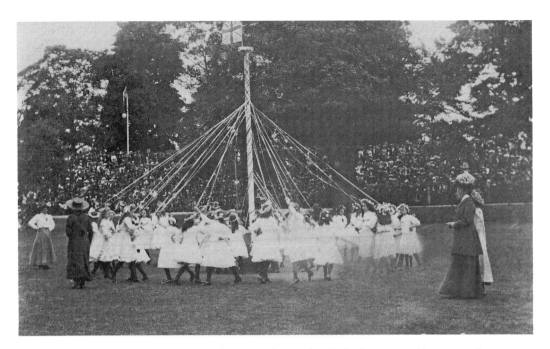

In this 1911 Coronation Day postcard picture taken on the Castle Green, over thirty young dancers perform the Maypole dance. The card, though badly faded and damaged, shows their precision dancing around the Maypole.

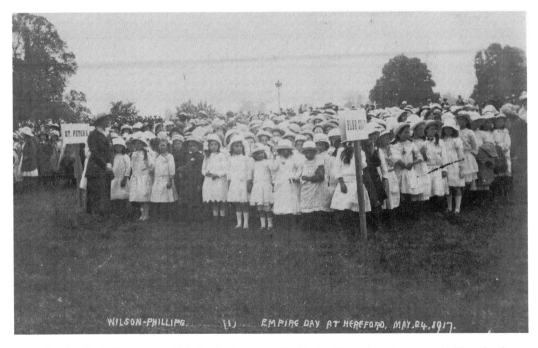

On the Castle Green, two girls' schools feature on this Empire Day celebration postcard. The schools are St Peter's and the Bluecoat. All the pupils are immaculately dressed.

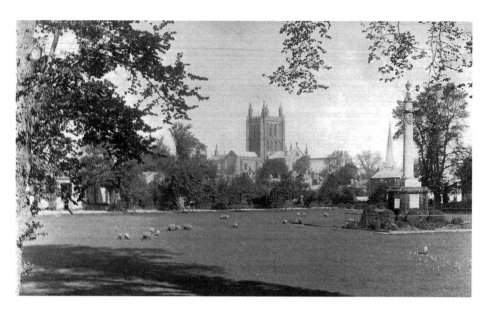

The Cathedral dominates this view from the Castle Green. On the right is Nelson's Column, paid for by public subscription and erected in 1809 to commemorate Viscount Lord Nelson's 1802 visit to Hereford. There were plans to put a statue of Nelson on the top, but not enough funds were raised, so a cheaper urn was placed there instead. Three cannons captured at Sebastopol stand at the base of the column. The grazing sheep act as a lawn mower.

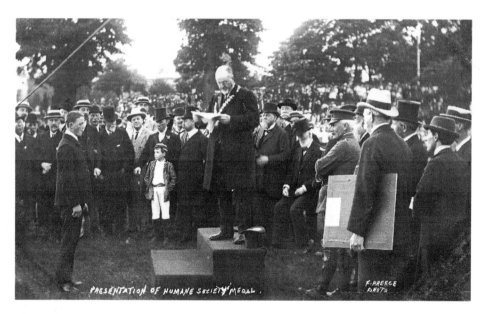

The Castle Green is part of the site of Hereford's ancient castle and also the ground where St Guthlac's stood, a minster church where the saint's body was buried around 715. Recent excavations found that the green was used as a burial ground from the sixth to the eleventh century. The grounds of the medieval castle, dismantled after the Civil War, were transformed into a pleasure garden by 1750. Here, the mayor, Mr J. Mitchell, is seen presenting the Royal Humane Society Medals for lifesaving on 13 June 1908.

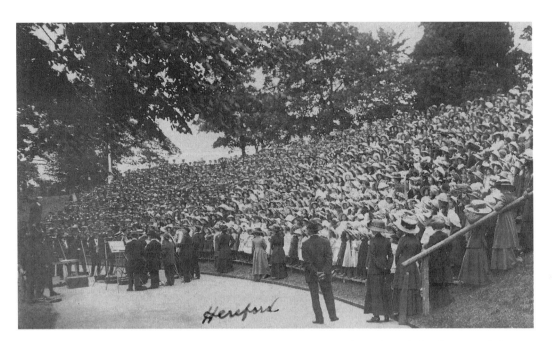

The high rampart on the Castle Green known as Hogg's Mount formed an ideal audience amphitheatre for the musical concert on 1 July 1911. There is clearly a division of sexes with the males to the left, girls to the right and the small children at the front.

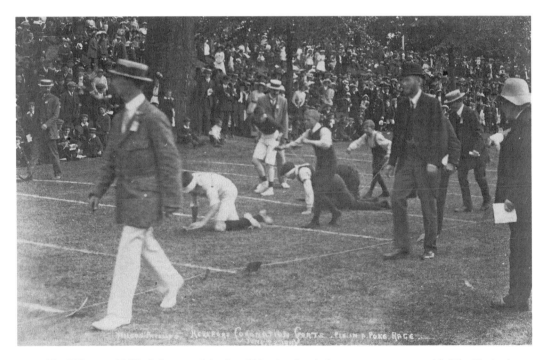

The Wilson & Phillips' photographer placed his tripod and plate camera very near this 'The Pig in the Poke' race to take this picture. It looks as if there are more officials than competitors. Wilson & Phillips were a post office, printers and general stationery shop in Eign Street.

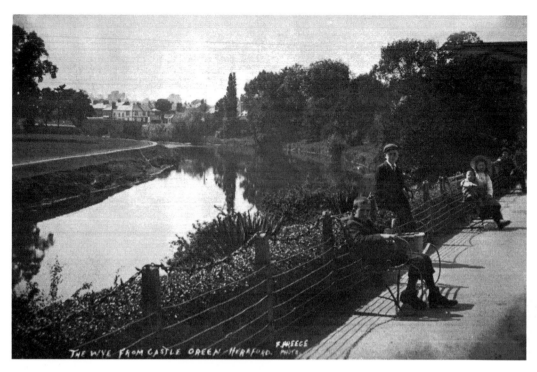

The two boys on the Castle Green have a wicker hamper. In the distance is the Wye Bridge built in 1490, the oldest on the river. The bishop owns the meadow on the opposite bank.

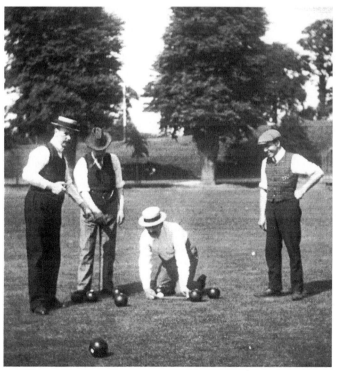

The Hereford City Bowling Green (on the Castle Green) was opened in May 1908. Amongst those present were: the Mayor, Mr J. Mitchell, who performed the opening ceremony; Mr Earnest Heins, whose family owned a music shop in Broad Street; Mr W.R. Bulmer; and Mr W.J. Gurney who owned the largest grocery shop in Hereford. This photograph was taken soon after the opening. It is interesting to see that there are no fences surrounding the green. The bank in the background is part of the castle ramparts. The oldest bowling green in the city (recorded in 1697) is just to the north of All Saints church in Bewell Street.

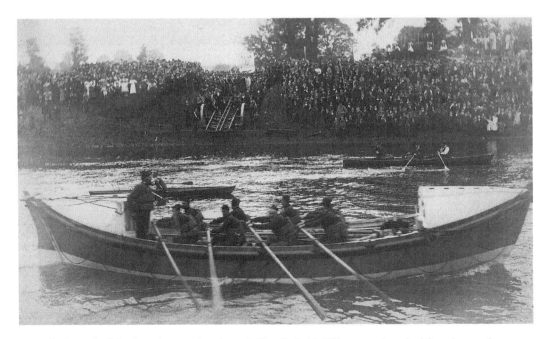

Mayor Edward Fredrick Bulmer and civic dignitaries on the bandstand watch the lifeboat, drawn by four horses, pass by on its way to the river Wye where it would be launched and rowed by a crew of eight. In front of the black and white house is a horse-drawn double-deck omnibus with its top deck full of spectators.

At the end of the formal procession through Hereford, this lifeboat was launched from its wooden cart on the Castle Green bank onto the river Wye. All the crew are wearing cork life jackets, while those in the pleasure boats are not. There are no barriers to protect the crowds on the steep bank.

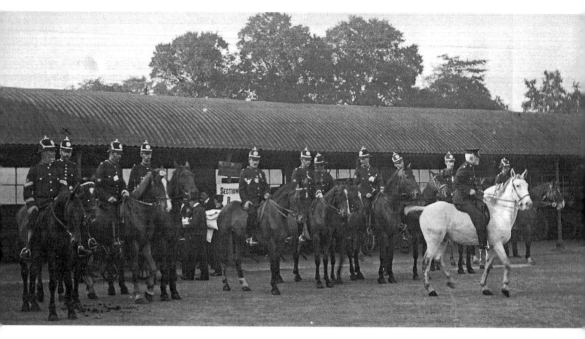

The Cattle Market is the assembly area for the lifeboat Saturday fundraising parade. The mounted police get ready for the event while the officer in charge has a little trouble with his horse.

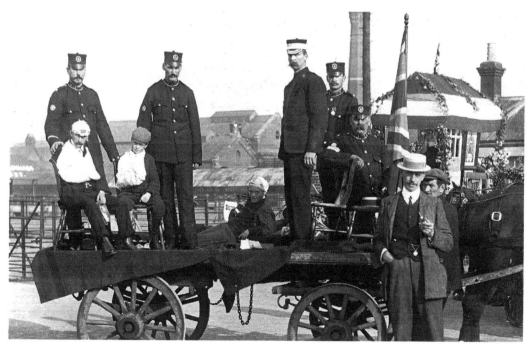

Unknown uniformed men on their Lifeboat Sunday horse-drawn float. Their young 'casualties with arm slings' are happy to pose for the photographer. The Cattle Market pens are in the background.

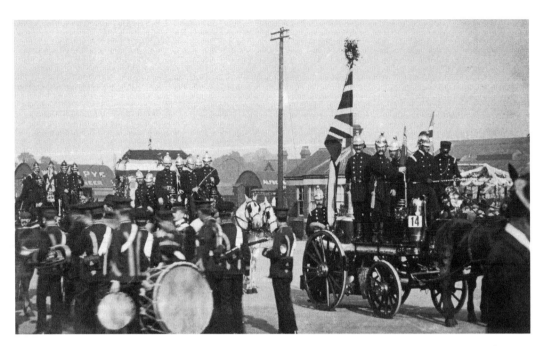

The grand Lifeboat Sunday carnival procession assembled in the Cattle Market. Here in Newmarket Street are three steam-powered fire engines with their crews. Note the distant roof sign advertising auctioneer Walter Pye.

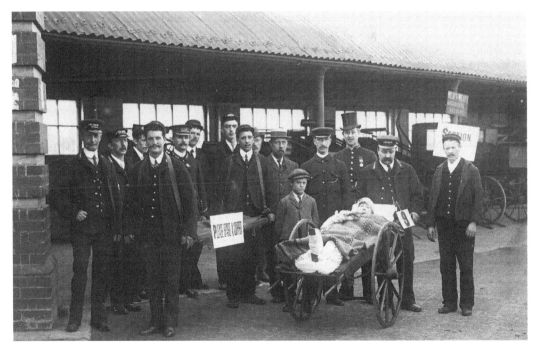

Railway workers assemble in the Cattle Market for the Lifeboat Sunday parade. Here the centre of attraction is a casualty covered in bandages, lying on a handcart. The sign begs, 'please spare a copper'.

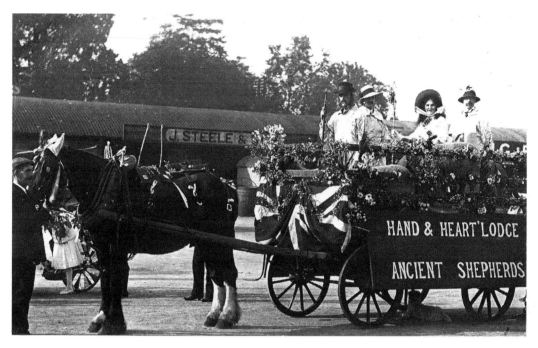

The hand and heart lodge ancient shepherds float waits in the Cattle Market for the start of the Lifeboat Saturday carnival parade to High Town. In the background is J. Steele & Sons, agricultural implement manufacturers.

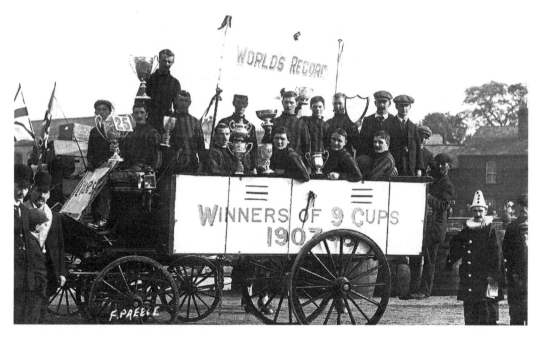

The photographer has captured the happy faces of this world record team before the grand parade on Lifeboat Sunday. Their prize-winning silverware is on display and a clown looks on. The author has been unable to discover details of this pre-'Guinness' world record.

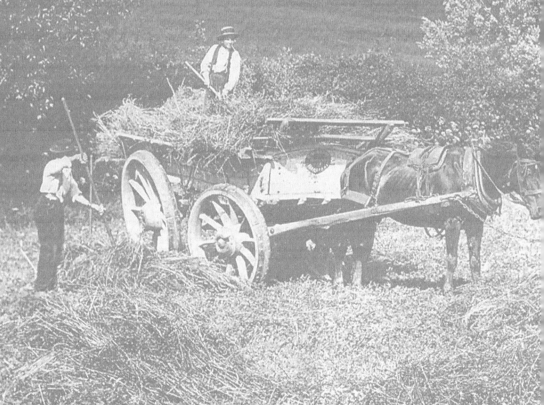

eight

Around
and About

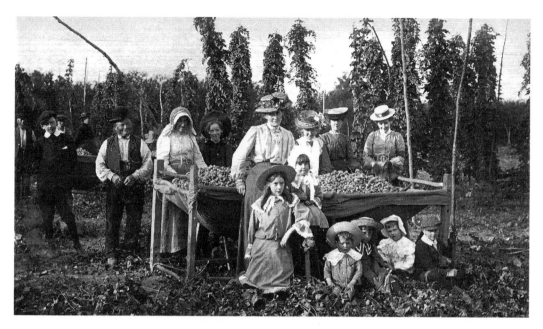

During the past 400 years Herefordshire hops were grown in at least 80 per cent of the county's parishes. The hop belongs to the same family as hemp and cannabis. The pickers proudly pose behind the full crib with their children in front. The unpicked bines in the background are growing on poles.

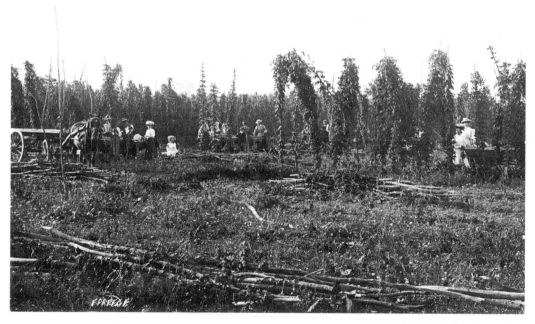

Many hop-pickers came by rail from the West Midlands and South Wales. A group, often made up of family and friends, manned each crib. When the hops were ready for picking, the poles were lowered, as seen in the foreground, and then a horse and cart would take the hops to the farm kiln for drying. Three cribs are visible in this view.

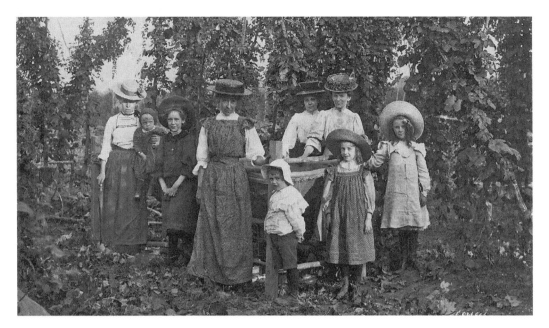

Ale, with a low alcohol content, was the country's main drink before the sixteenth century. The brew was quite weak, and was drunk instead of contaminated water. The hops used to flavour and preserve it originally came from Europe and were grown here from around 1550. The sheltered river valleys of the Frome and Lugg grew the best hops. These hop-pickers are in a hop yard just outside Hereford.

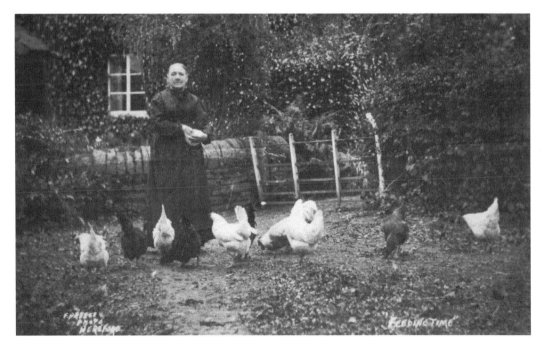

An unknown woman is the focal point for this photograph from around 1910. She has just fed her hens, and posed for photographer Preece. This scene could be in any smallholding near the city. The author would welcome its identification.

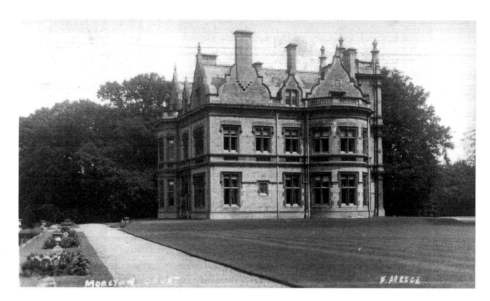

Moreton Court, situated on the north side of Moreton on Lugg, is three miles north of Hereford. In 1832 the Court had a small park and belonged to William Chute Gwinnett. In 1861 Thomas Evans bought Gwinnett's estate and further land from the Ecclesiastical Commissioners to create an estate of nearly 1,000 acres. A few years later he built an, 'elegant mansion in the Italian Elizabethan style', employing the architect J.H. Knight of Cheltenham. The house, described as an elegant mansion in the Italian Elizabethan style, was L-shaped with a stone tower. In 1914 its owner was Mrs Hill. (David Whitehead – *Historic Parks and Gardens in Herefordshire*)

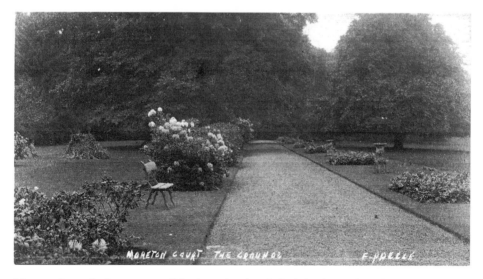

Moreton Court Gardens was a small, landscaped park. It had a belt of trees planted around Upper House Farm to the west, which followed the carriage drive to the house. The pleasure grounds, including a long terrace walk overlooking the park, were laid out to the west of the house and are described in a sale catalogue of 1928 as, 'very well timbered and laid out in broad lawns, affording space for three tennis courts'. There is a specially designed archery ground and beds of rhododendrons and other ornamental shrubs. (David Whitehead – *Historic Parks and Gardens in Herefordshire*)

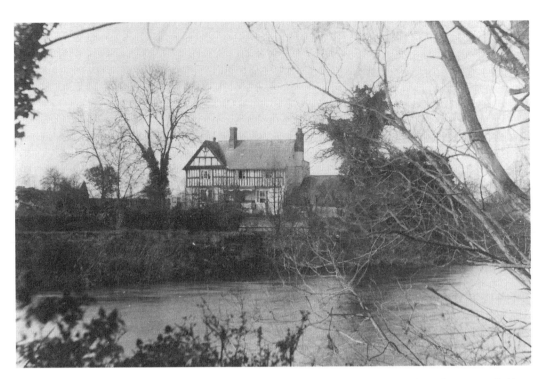

Putson Manor House on the bank of the river Wye, is half a mile down stream from the Victoria Bridge inside the city boundary. Built around 1600, it is an L-shaped, timber-framed house.

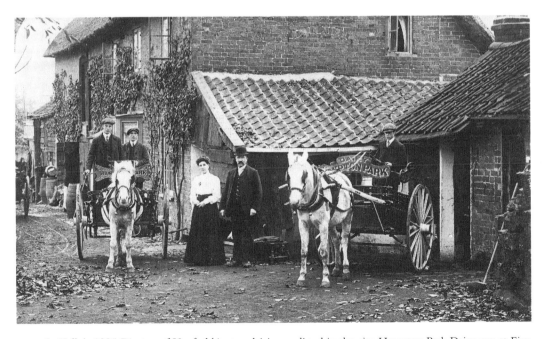

In Kelly's *1905 Directory of Herefordshire*, ten dairies are listed in the city. Hampton Park Dairy was at Eign Mill, adjacent to the Hampton Park Road railway bridge. Here, in a bowler hat, is George Preece, the owner, with his wife and three employees.

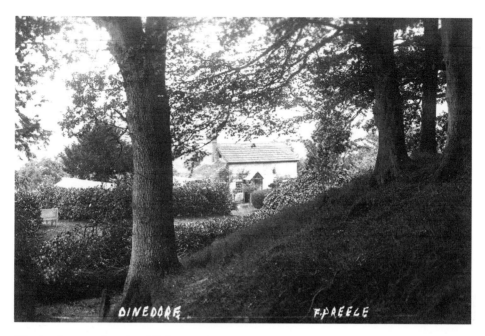

Dinedor Camp, an Iron Age hill fort, stands just over one mile south-west from the city boundary. During the Edwardian era it was a popular attraction and had a tea garden with panoramic views. In 1914 Mrs Elizabeth Wildman owned the Camp Tea Gardens.

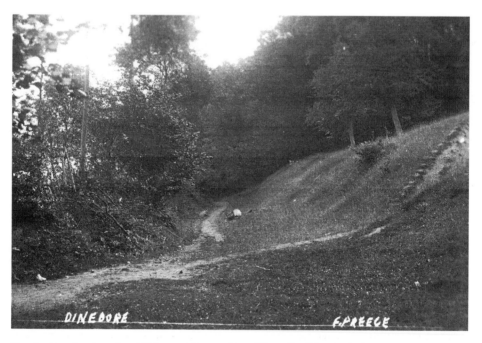

Hereford has four Iron Age hill forts within a radius of five miles. Dinedor is the nearest and most accessible. In 1912, Hereford Corporation purchased the camp from the trustees of the Bodenham family, who owned the Rotherwas estate. It is an oval shape and covers about 6½ acres inside the ramparts. The original entrance was at the extreme east end. The rampart and ditch is clearly visible.

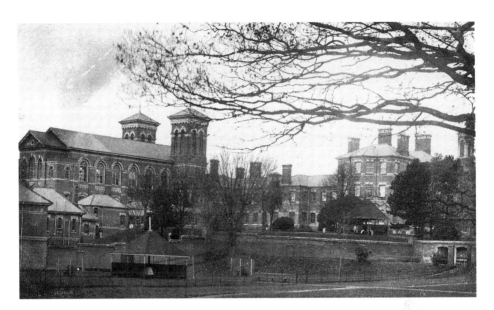

The Hereford City & County lunatic asylum in Burghill was three miles to the north-west of Hereford, and was built on 110 acres of farmland in 1868–72 at a cost of £88,000. By 1900 two new blocks were built to accommodate an additional one hundred female and fifty male patients. The hospital buildings occupied 10 acres and commanded extensive views of the surrounding countryside. In 1902 there were 300 females in six wards and 250 males in five wards.

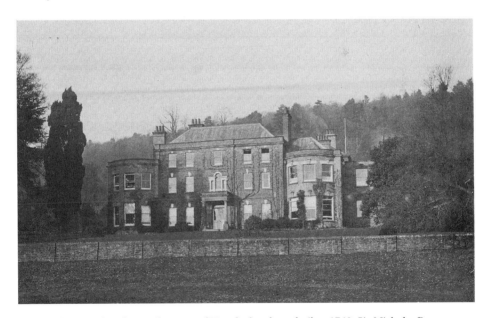

Credenhill Court lies three miles west of Hereford and was built c. 1760. Sir Nicholas Pevsner describes it as, 'of five bays and three storeys, red brick, central Venetian window, parapet and giant angle pilasters'. It was the seat of the Hardwicks and was built above the village on the south-facing slope of Credenhill Park Wood. The local directories noted, 'the extensive views that it enjoys, of the delightful scenery around'. In 1905 it was occupied by William Farrier Ecroyd JP, lord of the manor. (David Whitehead)

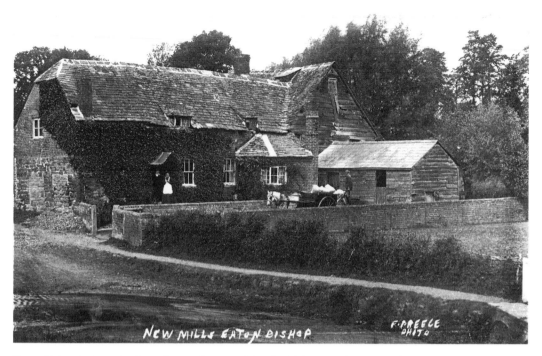

Eaton Bishop is situated a few miles south-west of Hereford. This view from around 1910 is of New Mills farm. Tom Lewis and his wife pose in their porch for the photograph. He was a miller and farmer at New Mills and Crossway Farm.

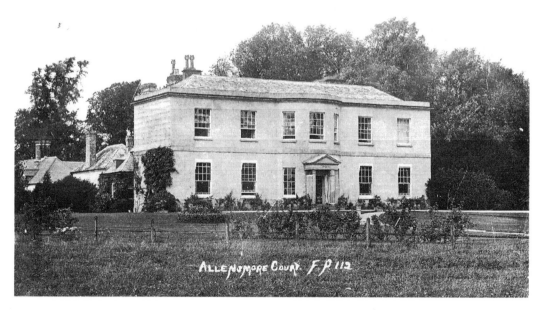

Allensmore Court stands three miles south of Hereford. The lord of the manor around 1910 was Capt. Harry Evan Pateshall. In 1782 a new range designed by the Hereford architect Thomas Symonds was added to the front of the existing Queen Anne house. (David Whitehead)

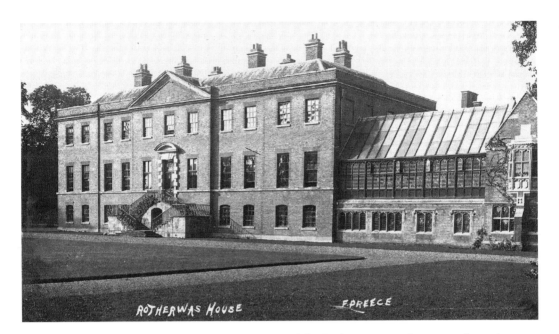

The Bodenham family owned Rotherwas House and the Rotherwas estate about two miles to the east of Hereford on the south bank of the river Wye. It had parkland that extended along the side of Dinedor Hill. In 1732 Charles Bodenham employed architect James Gibbs to build a new house that incorporated wood panels from the old house. There was a walled garden between the house and the river Wye. (David Whitehead)

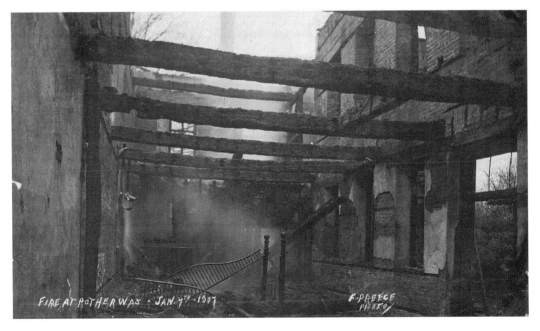

Rotherwas House, described as, 'situated in a beautiful park containing 200 acres', was an estate that at the turn of the century was a thriving agricultural holding. However, fire destroyed the house on 7 January 1907, and the ruins were finally demolished in 1926.

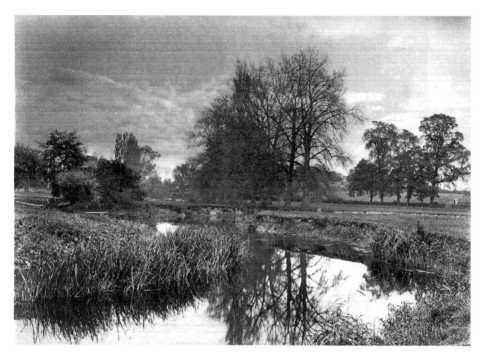

The river Lugg meanders near the city boundary at the foot of Aylestone Hill. This tranquil autumn scene shows the reflections of the trees in the water.

Farming has always been the main occupation in the county. The *Herefordshire Trade Directory* for 1900 lists about 3,000 farmers. Photographer Preece took this picture about 1900 somewhere near the city.

The Lugg meadows are flooded below the Hatton family home 'Kilburn' on Aylestone Hill. The Lugg Mills on the Worcester Road are visible to the right of the distant poplar trees.

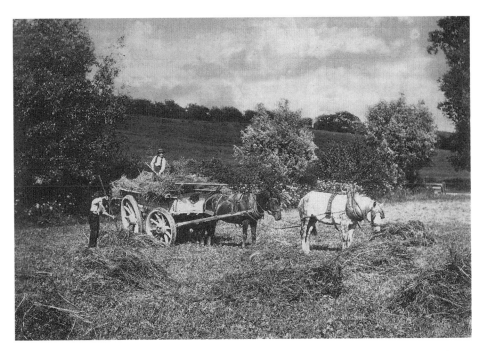

Photographer Edwin John Hatton and his family lived in 'Kilburn' on Aylestone Hill. He took this photograph on the Lugg meadows from behind his house. The two workers gather the late summer crop of hay while their horses wait.

Other local titles published by The History Press

Herefordshire Life

KEITH JAMES

Born in Herefordshire, photographer Derek Evans FRPS, FRSA is one of a crop of distinguished photojournalists who recorded Britain through the mid-twentieth century and beyond. This volume, the first release of pictures from his archives in fifty years, illustrates some of the Herefordshire people and places he photographed around the mid-1950s and will appeal to those who know the area and offer an insight into the area's past to those who do not.

0 7524 3724 0

Abergavenny Pubs

FRANK OLDING

Using images held in the archives of the Abergavenny Museum this illustrated volume of the town's pubs traces the development of the licensed trade in this fascinating area of Wales. *Abergavenny Pubs* will delight all those who want to know more about the history of the town's pubs, their clientele, landlords and ladies and take the reader on a fascinating journey into the past of their favourite local.

ISBN 0 7524 3576 0

Worcester

PAUL HARRISON

All aspects of everyday life are recorded here, from shops and businesses, schools and hospitals, to pubs and hotels, work and leisure. Landmarks such as the city's eleventh-century cathedral, Lich Street and The Foregate, home to Worcester's Hop Market, are featured and events such as King George VI's Coronation celebrations in 1937.

0 7524 3726 7

The Malverns

BRIAN ILES

This charming collection of over 200 archive photographs documents life in the Malverns from the 1860s until the 1950s. The area is famous for its mineral water and became a popular place to 'take the waters' in the Victorian era. The 1930s saw the heyday of the Malvern film and theatre festivals which attracted actors such as Errol Flynn and Stewart Grainger to the area.

0 7524 3667 8

If you are interested in purchasing other books published by The History Press, or in case you have difficulty finding any of our books in your local bookshop, you can also place orders directly through our website
www.thehistorypress.co.uk